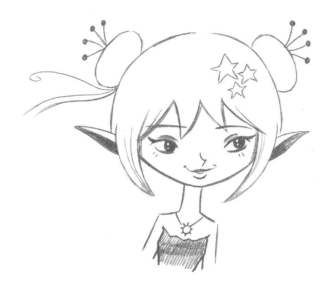

doodletopia
FAIRIES

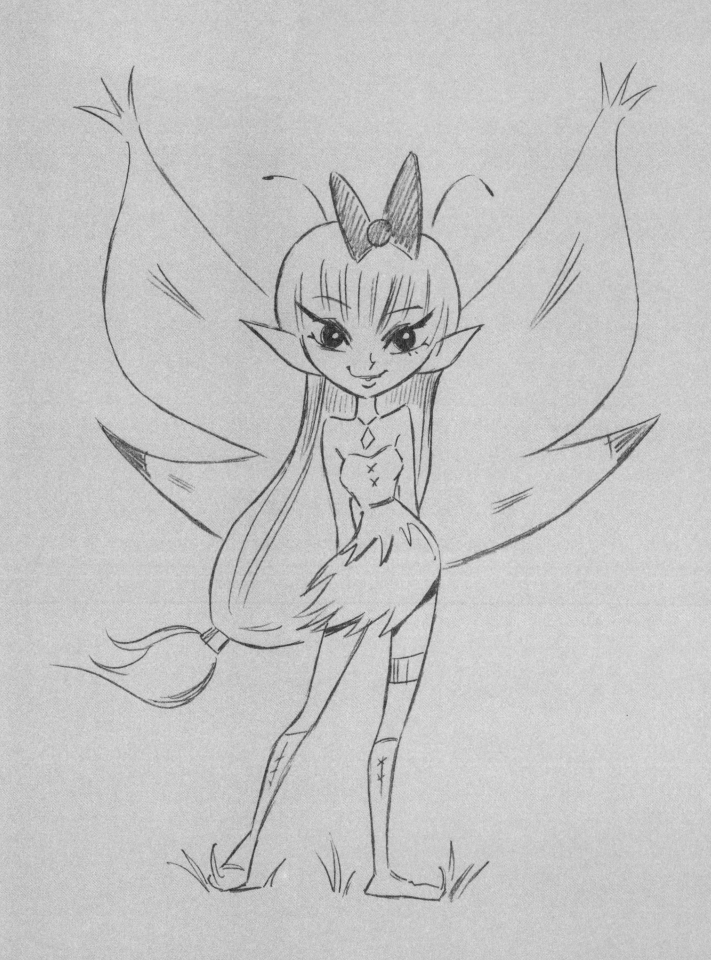

doodletopia
FAIRIES

**DRAW, DESIGN, and COLOR
Your Own SUPER-MAGICAL
and Beautiful Fairies**

CHRISTOPHER HART

WATSON-GUPTILL PUBLICATIONS
Berkeley

Contents

Introduction

Everyone loves fairies, those spry, small spirits that inhabit the woods (and sometimes your pantry). In this edition of my Doodletopia series, I'll help you create your own drawings of the wonderful world of fairies. Along the way, you'll find plenty of pages on which you can create your own fairy doodles.

In the chapters ahead, I'll demonstrate how to draw fairy wings, design magical fashions, make flying poses, create charming fairy villages, produce magical effects in your artwork, and more. Remember: there are many types of fairies, from playful to malevolent. You'll learn how to draw all of them.

Indicating size and scale is another important technique—and one I use throughout this book. You'll learn how to position these little people against giant versions of flowers, butterflies, mushrooms, and other objects in order to create the illusion that your fairies are super-small. They're the ones who steal your sunglasses when you're not looking. I know—you thought you misplaced them. This is the book of all things "fairy." You're going to enjoy your journey into the realm of the little where big things happen.

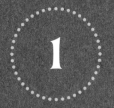

Complete Fairy Heads and Faces

Fairy faces are the same as yours and mine, with a few important differences. Their noses are so pointy they could double as weapons, their ears are humongous, and they've got buckets of flowing hair, as well as wings, conical hats, and, sometimes, antennae. Nonetheless, humans and fairies do have a lot in common.

Obviously, the first thing you need to do is to learn a little about the fairies' features so that you can draw them. For that, let's start with the head.

Girl Fairy: Front View

Fairies range in age from very young (about 633 years old) to mature ("It would be rude to tell."). This girl fairy has a wide face with small features, giving her a delicate look.

Draw wide eyes, giving her a bubbly appearance.

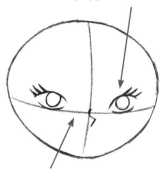

Draw her eyebrows high up on her head.

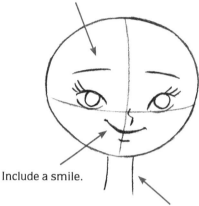

Include a full hairstyle.

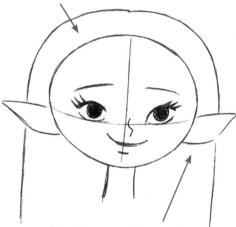

Sketch an eye line across the middle of her head for the eyes, and add another line—a center line—up and down.

Include a smile.

Add a long, thin neck.

Draw her ears at an angle.

Don't forget short, choppy bangs and a twisting, conical hat.

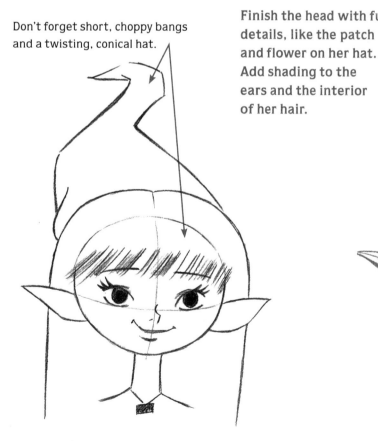

Finish the head with fun details, like the patch and flower on her hat. Add shading to the ears and the interior of her hair.

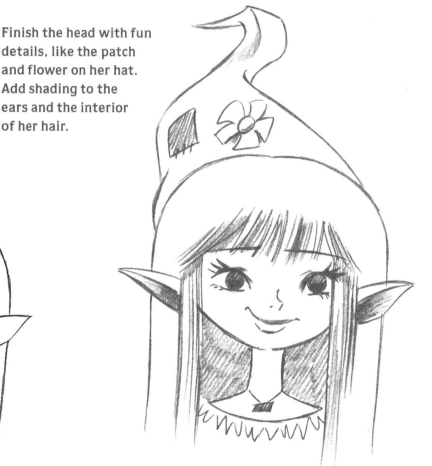

Finish This Fairy Head.

Doodle away! Complete the fairy's head and hair. When you're done, you can give the character a magical name—like Luna or Emerald.

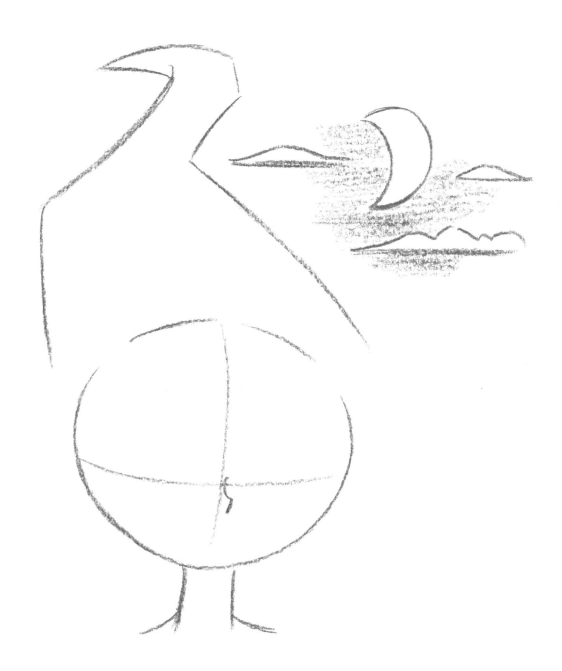

Girl Fairy: Side View

Now let's draw this fairy girl's head from a different angle: in profile, also known as a side view—and "the angle that drives people crazy." Let's break down the steps to make it easy to draw.

Add the eyebrow.

Tilt her pointed ears up at a diagonal.

Draw a swooping line from the back of the head to the tip of her nose.

Curl her smile upward.

Give her long, flowing hair. Lots of it.

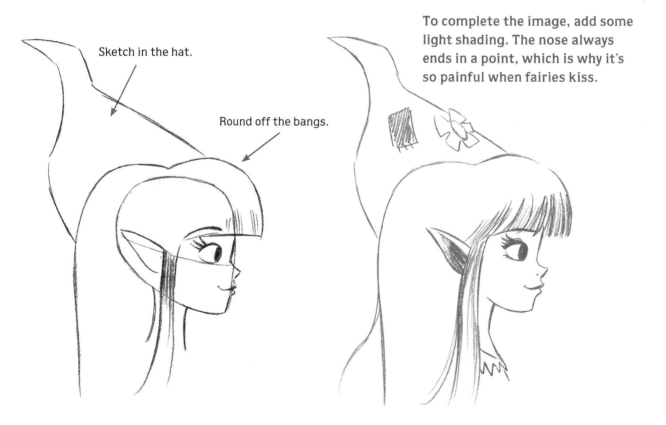

Sketch in the hat.

Round off the bangs.

To complete the image, add some light shading. The nose always ends in a point, which is why it's so painful when fairies kiss.

Finish This Fairy Head.

Create some magic. Your pencil is your wand. And your eraser is . . . still just a rubbery thing. But your pencil is a wand! Draw pointed ears angled up. The eyes should also appear somewhat pointed.

Boy Fairy: Front View

Fairies are brave. They aren't afraid of anything. (Except a vacuum cleaner.) In this example, notice how I've drawn the fairy's eyes: tilted up at the ends. This makes it seem like the fairy is looking in the direction of the butterfly above his head. Male fairies have boyish haircuts, and eyes that, though tapered, have no eyelashes.

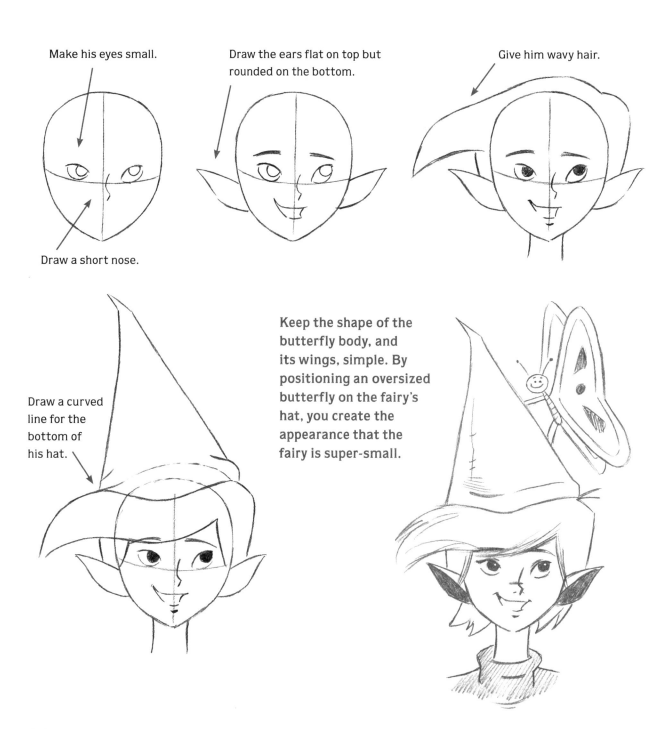

Make his eyes small.

Draw a short nose.

Draw the ears flat on top but rounded on the bottom.

Give him wavy hair.

Draw a curved line for the bottom of his hat.

Keep the shape of the butterfly body, and its wings, simple. By positioning an oversized butterfly on the fairy's hat, you create the appearance that the fairy is super-small.

Finish This Fairy Head.

Now it's your turn. Fill in the features and details by following the steps on the preceding page. Draw the butterfly's wings the length of the fairy's hat. Butterflies are almost weightless, so this one won't leave an indentation on his hat.

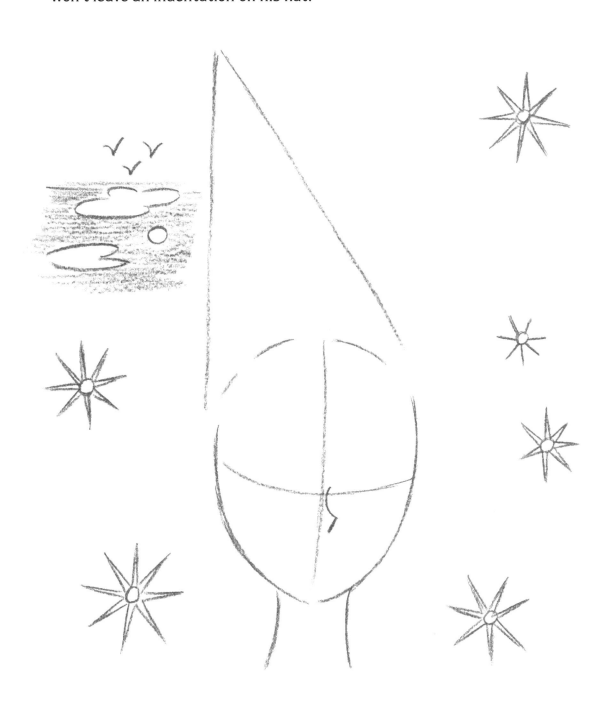

Boy Fairy: Side View

Looking at the head from the side, you'll see that fairies have deeply curved, long noses. That causes them no end of trouble during hay fever season. The fairy's eyes are long from side to side but short from top to bottom.

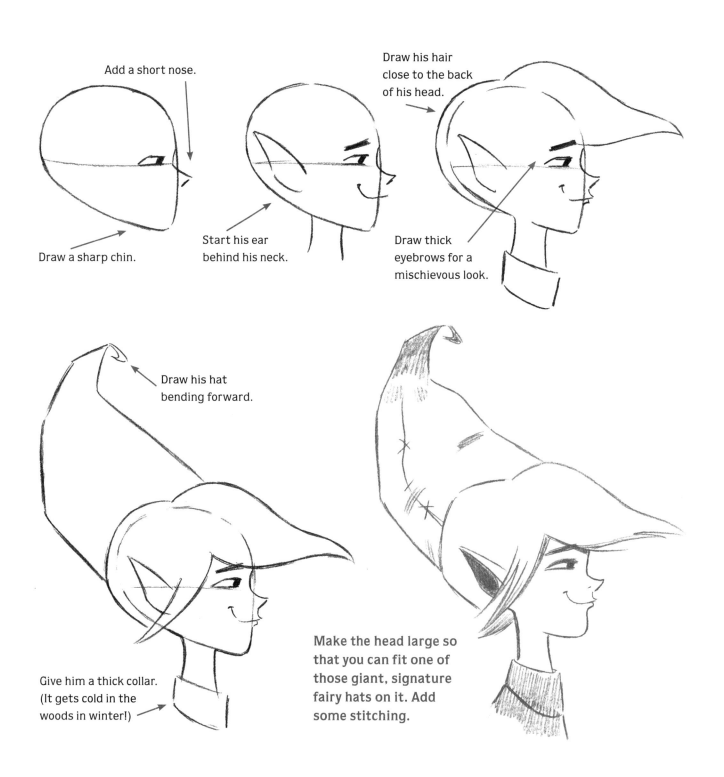

Add a short nose.

Draw a sharp chin.

Start his ear behind his neck.

Draw his hair close to the back of his head.

Draw thick eyebrows for a mischievous look.

Draw his hat bending forward.

Give him a thick collar. (It gets cold in the woods in winter!)

Make the head large so that you can fit one of those giant, signature fairy hats on it. Add some stitching.

Finish This Fairy Head.

I don't know what he's thinking, but if I were you, I'd cover up that pie sitting on the kitchen counter and lock the pantry. Finish the image below, focusing on his upturned nose, slender eyes, and floppy hair.

More Fairy Faces

Now you can take your newfound knowledge of fairies and draw a few more heads and faces. These exercises will help get your pencils fully warmed up. Give each fairy a slightly different look. Doing so makes them more interesting to draw and more interesting for viewers as well.

Oval-Faced Fairies Are Fun

Many people use a circle as the head shape. But the oval is sometimes more interesting, because it's asymmetrical. It's fatter on one end and thinner on the other.

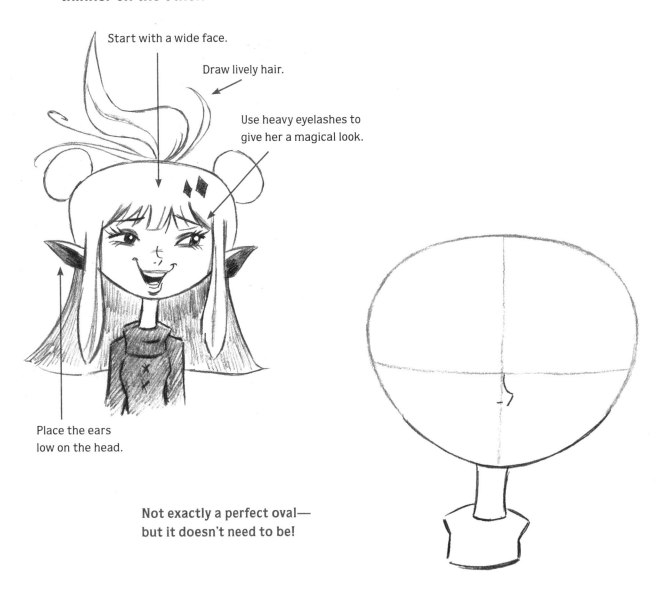

Start with a wide face.

Draw lively hair.

Use heavy eyelashes to give her a magical look.

Place the ears low on the head.

Not exactly a perfect oval— but it doesn't need to be!

Angular-Faced Fairies Are Confident

This little guy has complete confidence in his ability. He can do anything you ask him to do. He just can't do it well. The lines of the face converge at a sharp chin, which gives him a self-assured look.

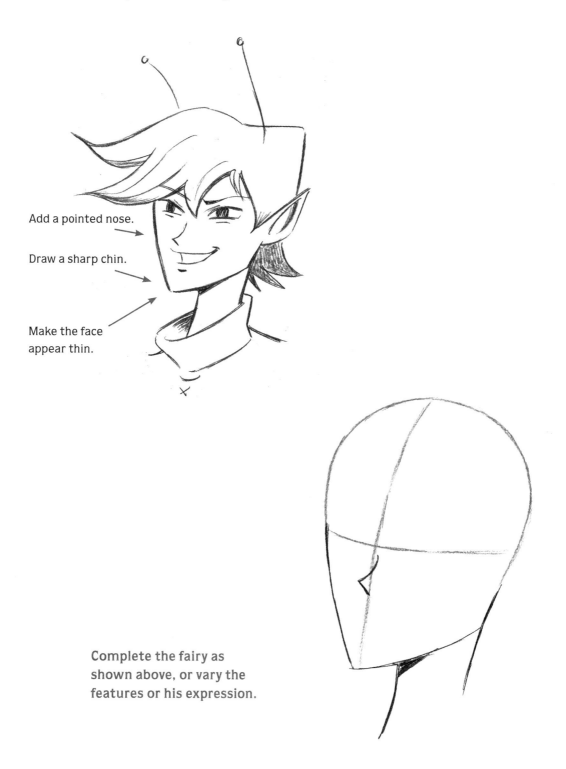

Add a pointed nose.

Draw a sharp chin.

Make the face appear thin.

Complete the fairy as shown above, or vary the features or his expression.

Round-Faced Fairies are Perfect at Pouting!

Fairies are easily upset. They're emotional beings. This little fairy is annoyed because she isn't getting exactly what she wants. To calm her down, treat her like any human teenager: *give her exactly what she wants.* Note the small chin. It's small because I've rounded it off into the rest of the head shape.

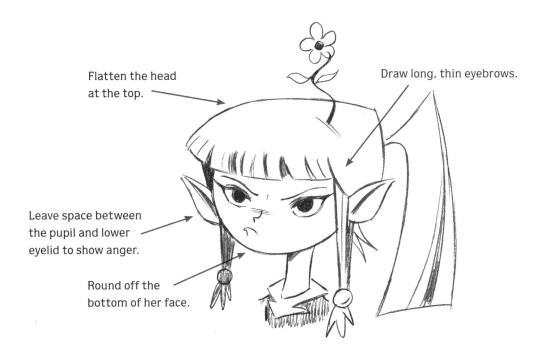

Flatten the head at the top.

Draw long, thin eyebrows.

Leave space between the pupil and lower eyelid to show anger.

Round off the bottom of her face.

Have fun with it. There are many types of angry mouth expressions. In these expressions, an angry mouth is pushed up by the lower lip. Try varying them.

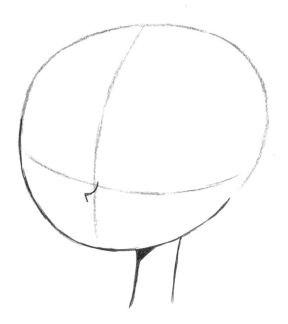

Young Faces *Look* Innocent

Unlike humans, fairies look young and perky for hundreds of years. It's mainly due to their healthy diet, consisting of roots, berries, and pinecones. Of course, they would trade it all for a burger in a nanosecond. Remember: young faces have a soft look—no hard angles.

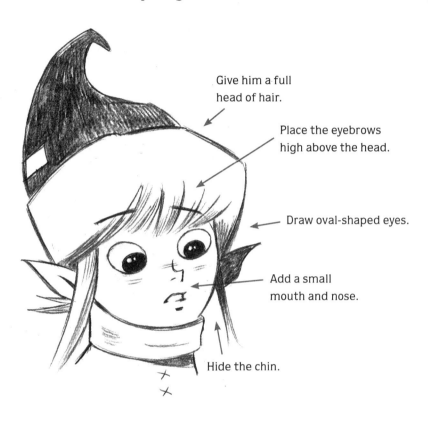

Give him a full head of hair.

Place the eyebrows high above the head.

Draw oval-shaped eyes.

Add a small mouth and nose.

Hide the chin.

Keep this young character simple for an effective look.

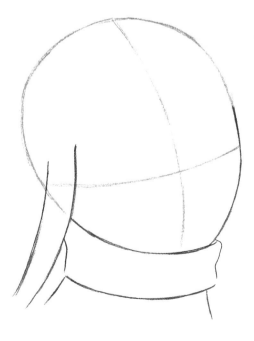

Fairy Ears

Fairies have large, pointed ears that allow them to hear danger coming from miles away. Their ears come in a variety of shapes. Here's a selection of the most common ones.

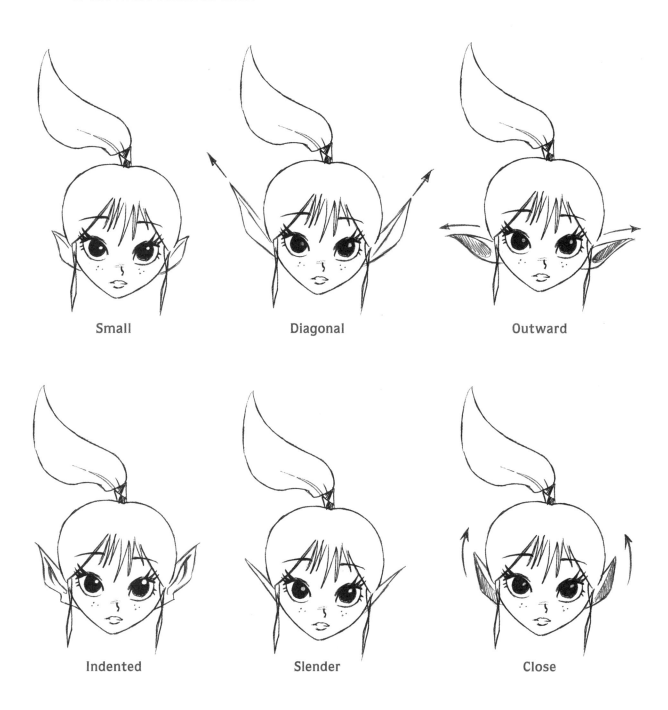

Small

Diagonal

Outward

Indented

Slender

Close

Draw Your Own Fairy Ears.

Try a variety to see which are your favorites. Then take it a step further and finish the eyes, hair, and the rest of the character.

EARS TIP
Be sure to line up the top and bottom of the left ear with the top and bottom of the right ear.

Enchanted Hairstyles

Fairy hairstyles are important for what they add to fairies' overall looks. I once saw a fairy with a plain haircut walk past a group of other fairies who snickered mercilessly. Don't let that happen to your character! Check out these options for cool hairstyles.

Curly

Draw the hair as if it were pouring out of the hat and all over the fairy's head. Draw big, round curls, not small ones. Part it in the middle. This hairstyle frequently covers up some of the outline of the head; therefore, don't let the head shape restrict your creativity. Let the hair go where it wants to go.

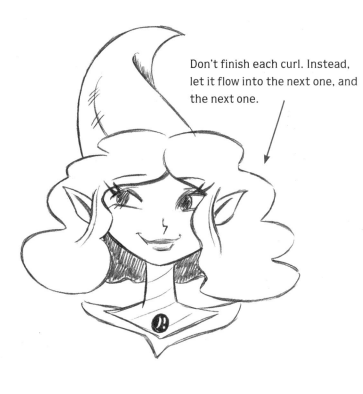

Don't finish each curl. Instead, let it flow into the next one, and the next one.

The hair in this style will obscure part of the face when finished.

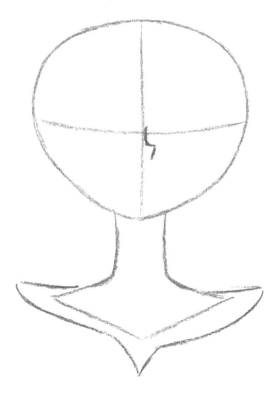

Letting It Grow Out

If fairies don't get a trim every few days, their hair tends to grow unwieldy. Super-long hair is rarely curly, because the sheer weight straightens it out.

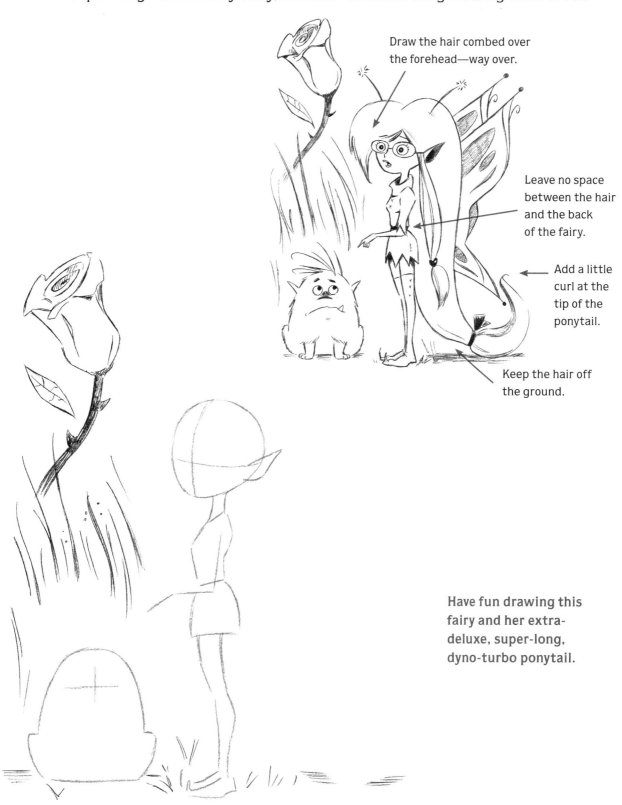

Draw the hair combed over the forehead—way over.

Leave no space between the hair and the back of the fairy.

Add a little curl at the tip of the ponytail.

Keep the hair off the ground.

Have fun drawing this fairy and her extra-deluxe, super-long, dyno-turbo ponytail.

Accessorized

Fairies like to add a lot of pretty accessories to their hair. You can add anything you like to your fairies' hair, such as stars, moons, hearts, or strawberries. But be forewarned: the strawberries are a bird magnet!

Smooth and round off the top of the head.

Draw hair over most of the head.

Add ruffled bangs.

Leave a few errant strands of hair coming out of the buns.

Notice how much room there is above the nose.

Draw her hair curving around her face.

Make her accessories a little chaotic, but it must be a "controlled chaos." Plan the look.

Flowing Hair

For a fun look, place her arms between the strands of hair. Of course, you could cut her hair. But then, she'd get even.

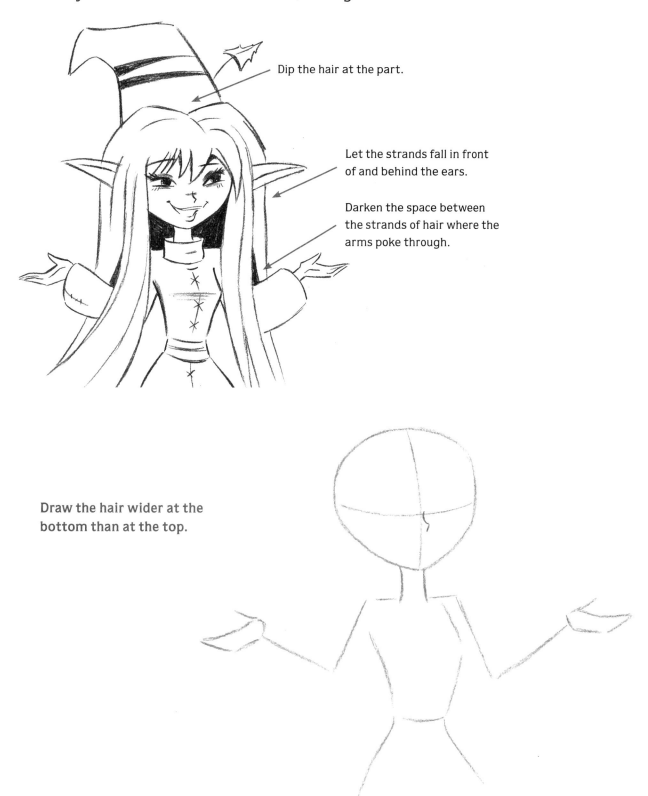

Dip the hair at the part.

Let the strands fall in front of and behind the ears.

Darken the space between the strands of hair where the arms poke through.

Draw the hair wider at the bottom than at the top.

Medieval-Style Braids

In the Middle Ages, fairies invented a new look: braids that wrapped around their heads. Humans then stole that look and took sole credit for it.

On the other hand, the buzz cut is strictly a human invention. Fairies have yet to claim credit for that one.

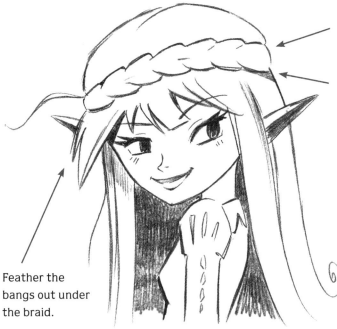

Draw the braids high on the forehead.

To indicate the roundness of the head, set the ring of braids on a curve, rather than on a straight horizontal line.

Feather the bangs out under the braid.

Use shading to bring out the dimensions of this hairstyle.

Light and Silky

Soft, supple, and silky hair is a sought-after look in the fairy kingdom. It takes conditioner that's one-third nectar, one-third bee pollen, one-third fairy sparkles, and also some eye of newt. You can never have too much newt. This silky look features hair all flowing in the same direction.

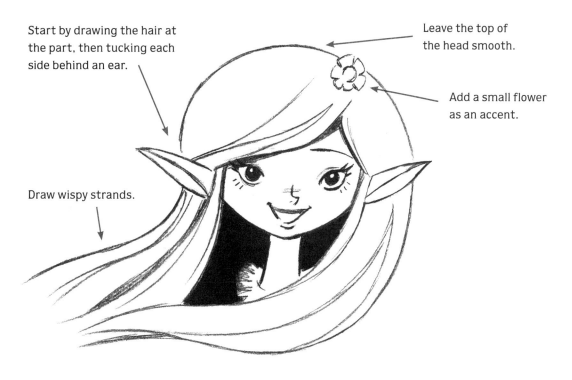

Start by drawing the hair at the part, then tucking each side behind an ear.

Leave the top of the head smooth.

Add a small flower as an accent.

Draw wispy strands.

Be delicate in drawing the hair here. You can draw two or three lines together, if they are wispy.

Ponytail

Fairies wear their ponytails way up high as they walk through the tall grass so that other fairies will be able to spot them. These ponytails look huge to fairies—almost an inch and a half in height. They also give the fairies a perky appearance. You can draw your fairy's ponytail with a tapered or shaggy look.

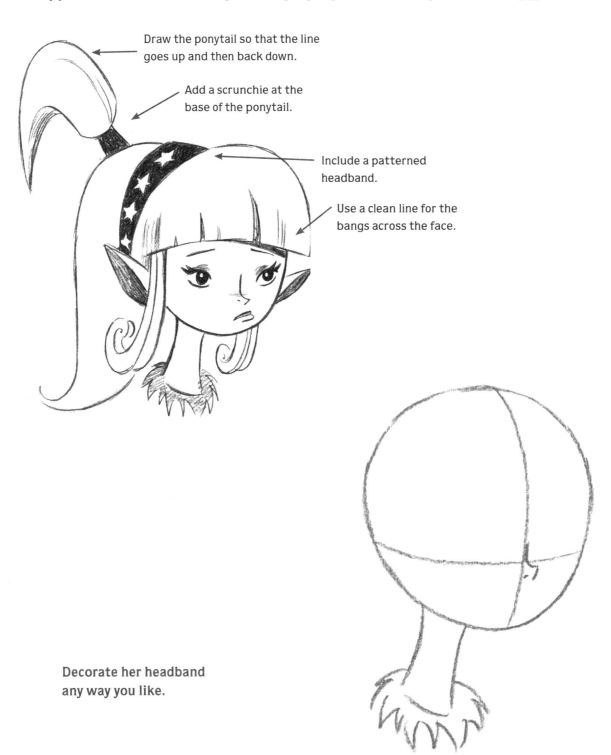

Draw the ponytail so that the line goes up and then back down.

Add a scrunchie at the base of the ponytail.

Include a patterned headband.

Use a clean line for the bangs across the face.

Decorate her headband any way you like.

Shaggy

Here's a fun and lively hairstyle. It starts as a bob but the final style includes random ruffles at the bottom of the bangs. Draw the hair that's over the ears so that it is longer than the bangs. There aren't any long strands or curly parts to this short hairdo.

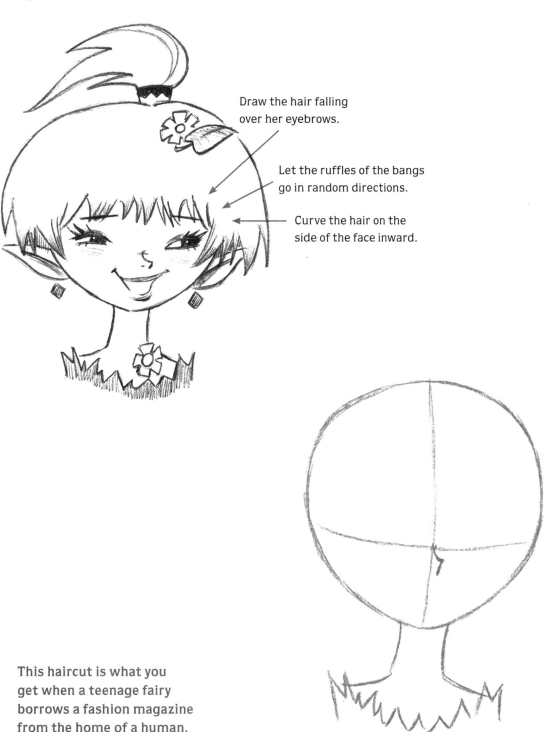

Draw the hair falling over her eyebrows.

Let the ruffles of the bangs go in random directions.

Curve the hair on the side of the face inward.

This haircut is what you get when a teenage fairy borrows a fashion magazine from the home of a human.

Antennae

Some fairies have antennae, which they use to sense sounds off in the distance. They also help the fairies navigate when they're flying. Fairies, being fashion conscious, prefer their antennae to be stylish.

In this section, I'll show you examples of fairy heads with various styles of antennae attached. You'll complete the construction images to create the characters and their antennae. You can follow my examples or create your own designs.

Mini Antennae

These are perfect for when you're in a rush and don't have time to put on anything else. With mini antennae, fairies can sense danger coming from four inches away.

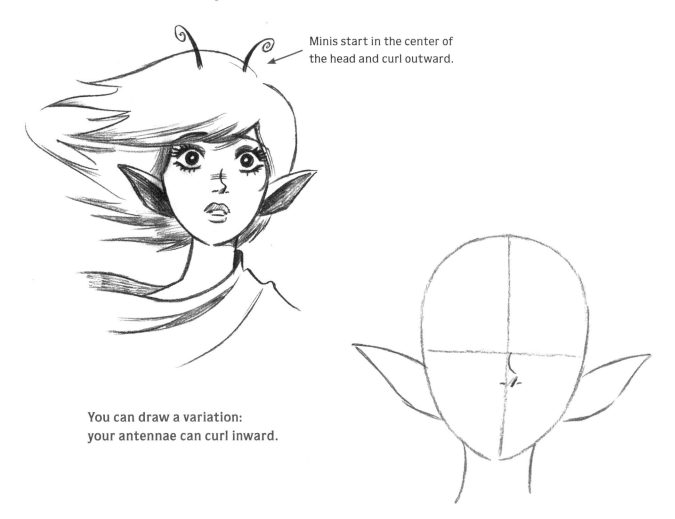

Minis start in the center of the head and curl outward.

You can draw a variation: your antennae can curl inward.

Decorated Antennae

These antennae are a little showy. They're worn mainly during holidays. Any decoration on the tip of an antenna will cause it to dip.

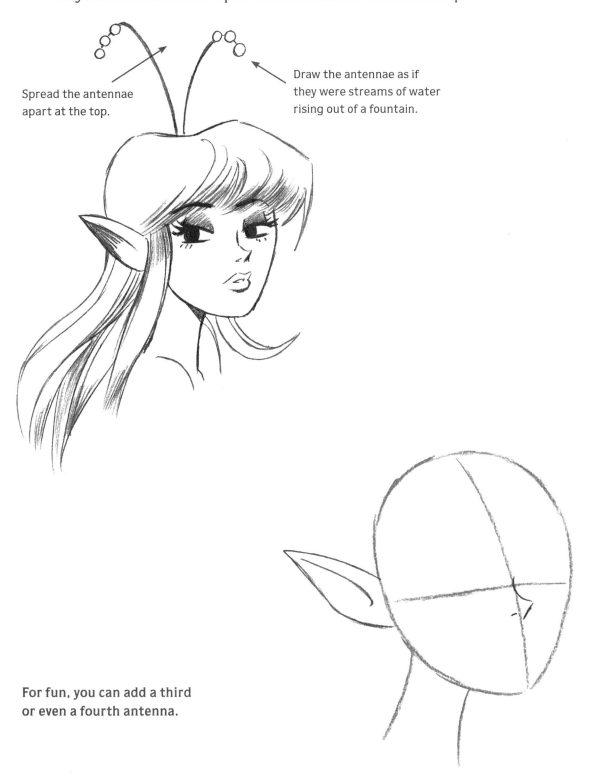

Spread the antennae apart at the top.

Draw the antennae as if they were streams of water rising out of a fountain.

For fun, you can add a third or even a fourth antenna.

Twirls

These antennae allow fairies to sense subtle movements in wind. They're great for warning of trespassing humans. They have a black weather-vane type of look to them.

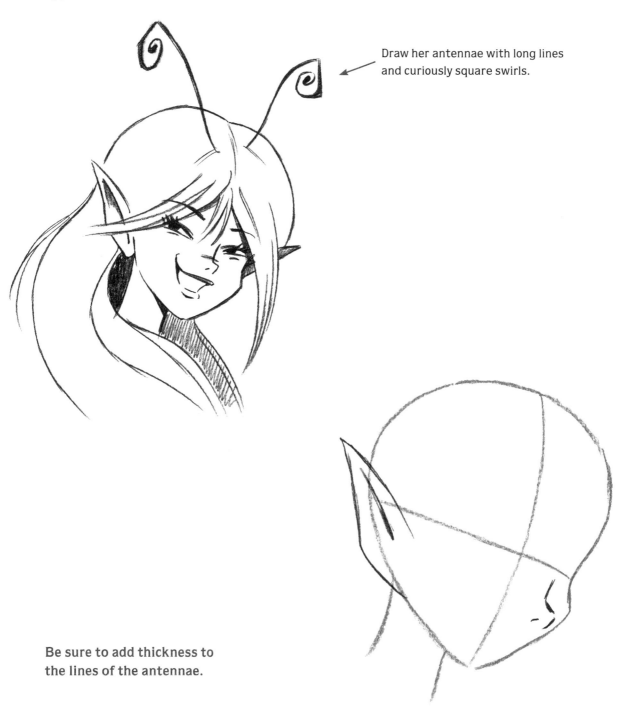

Draw her antennae with long lines and curiously square swirls.

Be sure to add thickness to the lines of the antennae.

Snowballs

These look like special snowball-style antennae, don't they? Hmm . . . nope. They're regular antennae for winter. That's what happens if fairies stand outside in the snow.

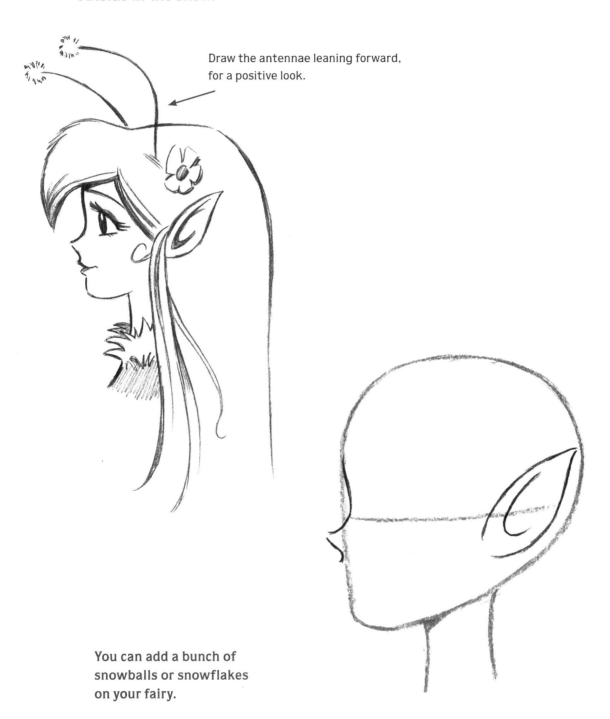

Draw the antennae leaning forward, for a positive look.

You can add a bunch of snowballs or snowflakes on your fairy.

Sprinkles

Add a little enchantment to the antennae with some sparkles. Draw little specs floating around them.

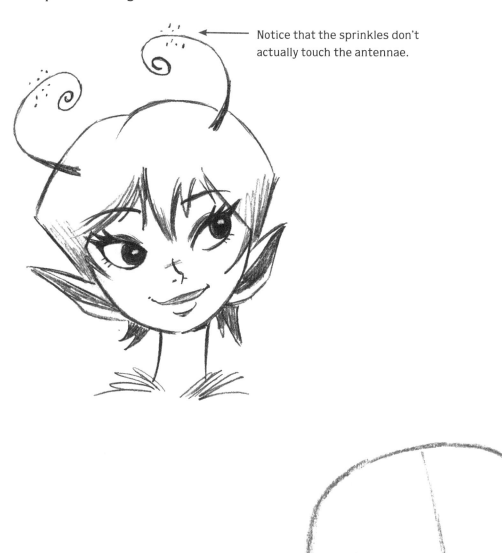

Notice that the sprinkles don't actually touch the antennae.

Use a wide base for these antennae.

Antennae as Jewelry

Antennae jewelry is the equivalent of earrings for fairies. Remember that the next time your fairy has a birthday coming up. If it's a really big piece, it's called "engagement antennae."

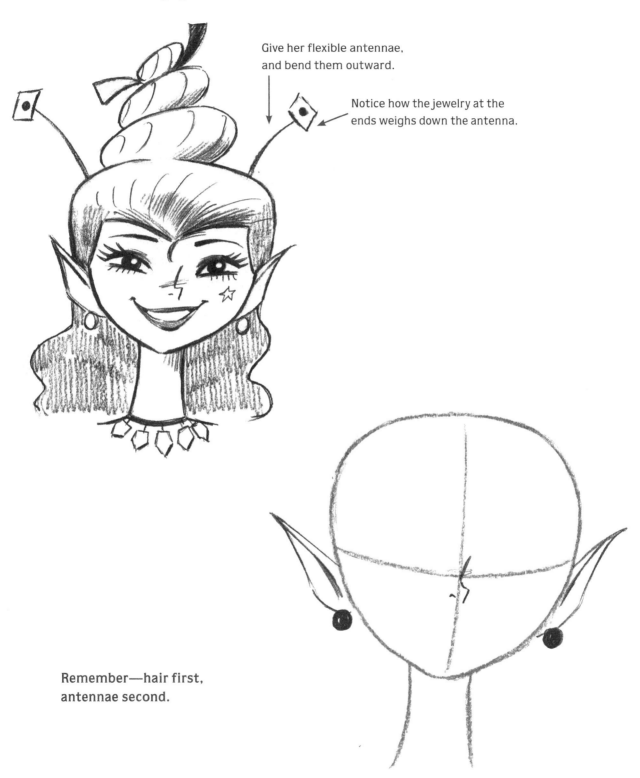

Give her flexible antennae, and bend them outward.

Notice how the jewelry at the ends weighs down the antenna.

Remember—hair first, antennae second.

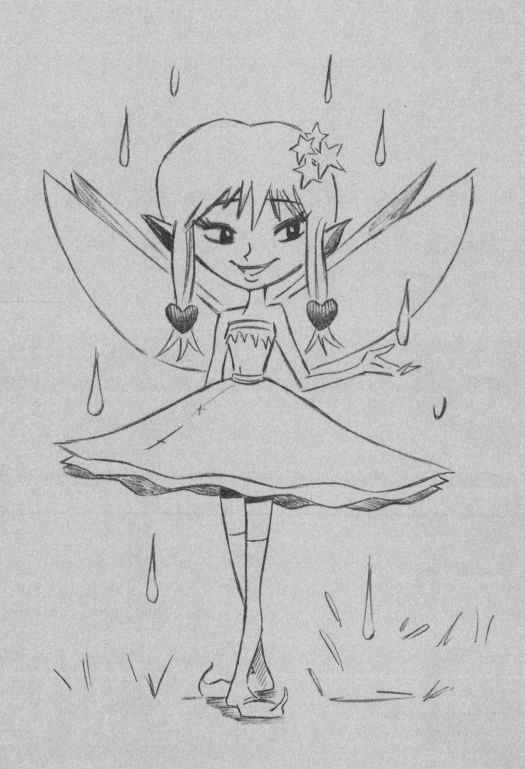

Draw Fairy Bodies

Now that you've mastered fairy heads and faces, it's time to draw their bodies. Fairy bodies are usually slender, the result of an all-flower diet. They have long limbs, which are great for flying . . . away from humans. In this chapter, I'll give you tips for doodling a variety of appealing fairy figures.

Just follow along with the pencil steps, and then apply them to the fairy constructions on the opposite pages.

Fairy Girl Body: Front View

Remember that the wings lift the fairy into the air—therefore, they have to appear big in contrast to the body. This is called the "wing-to-body" ratio.

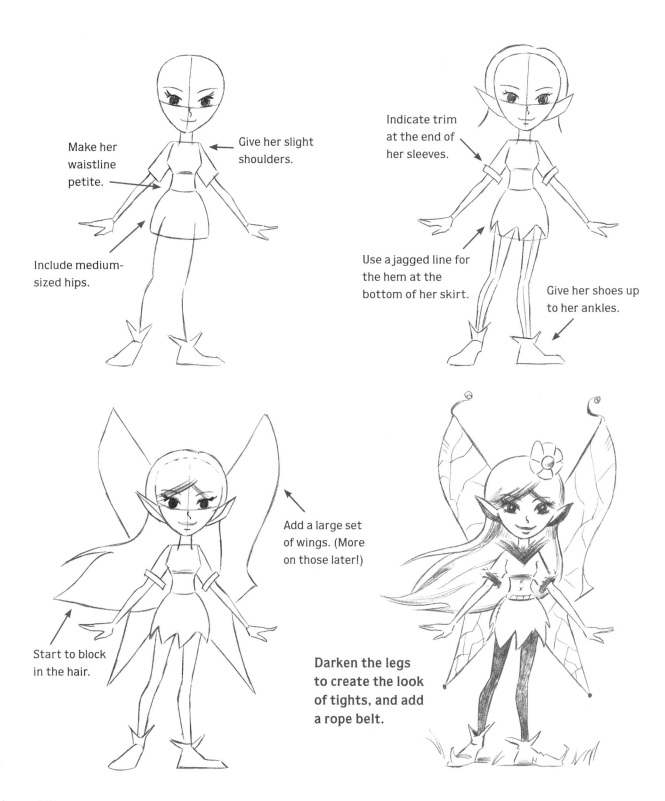

Make her waistline petite.

Give her slight shoulders.

Include medium-sized hips.

Indicate trim at the end of her sleeves.

Use a jagged line for the hem at the bottom of her skirt.

Give her shoes up to her ankles.

Add a large set of wings. (More on those later!)

Start to block in the hair.

Darken the legs to create the look of tights, and add a rope belt.

Draw Your Own Standing Fairy.

Draw your fairy girl facing forward. Sketch out the figure first, then the wings, and then go back and fill in all the details. Refer to the steps on the previous page as you draw.

Fairy Boy Body: Front View

The fairy boy's body is goofy looking. That's because he's a boy. It's part of his job description. Let me show you how to draw him.

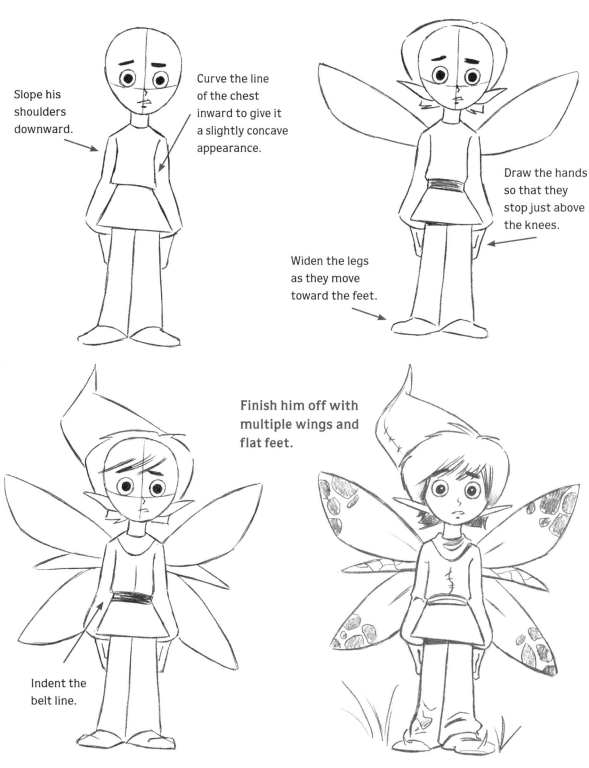

Slope his shoulders downward.

Curve the line of the chest inward to give it a slightly concave appearance.

Draw the hands so that they stop just above the knees.

Widen the legs as they move toward the feet.

Finish him off with multiple wings and flat feet.

Indent the belt line.

Draw Your Own Clueless Fairy.

Draw your fairy boy, facing front. A shaggy hairstyle makes him look a little perplexed, in a funny way. Press his arms and legs together for an insecure pose.

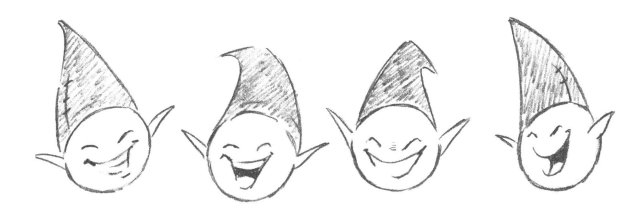

Fairy Girl Body: Side View

Some actions—like walking—look better from a side view. For this example, let's give this fairy a formfitting outfit so that you can better see how her body is constructed.

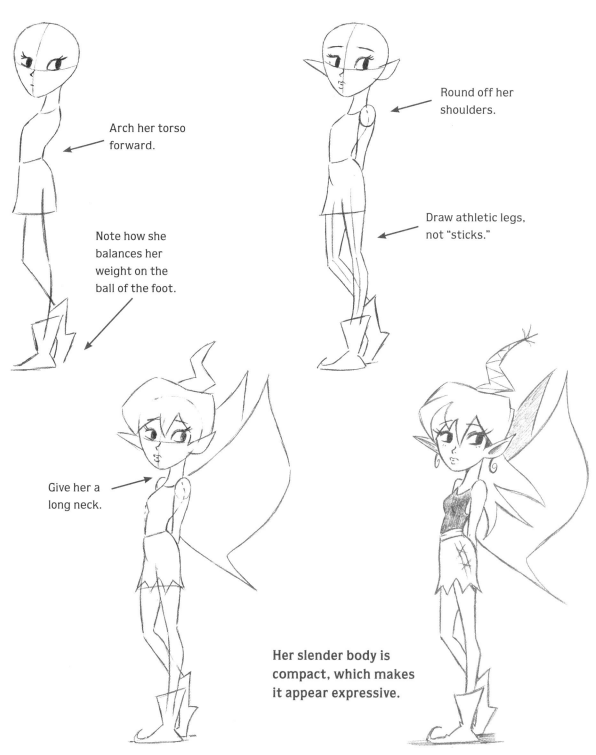

Arch her torso forward.

Note how she balances her weight on the ball of the foot.

Round off her shoulders.

Draw athletic legs, not "sticks."

Give her a long neck.

Her slender body is compact, which makes it appear expressive.

Draw Your Own Shy Fairy.

Draw your fairy girl, facing sideways. Typically, fairies have small torsos and long legs. You can adjust the proportions to create different types of characters.

Fairy Boy Body: Side View

Here's the male fairy in profile. From this view, you can see that he has a slender chest. He doesn't possess great physical powers. Instead, he relies on agility and dexterity to avoid danger from threats such as owls. If you're a fairy and an owl asks you for the time, it's never a good idea to look down at your watch to check.

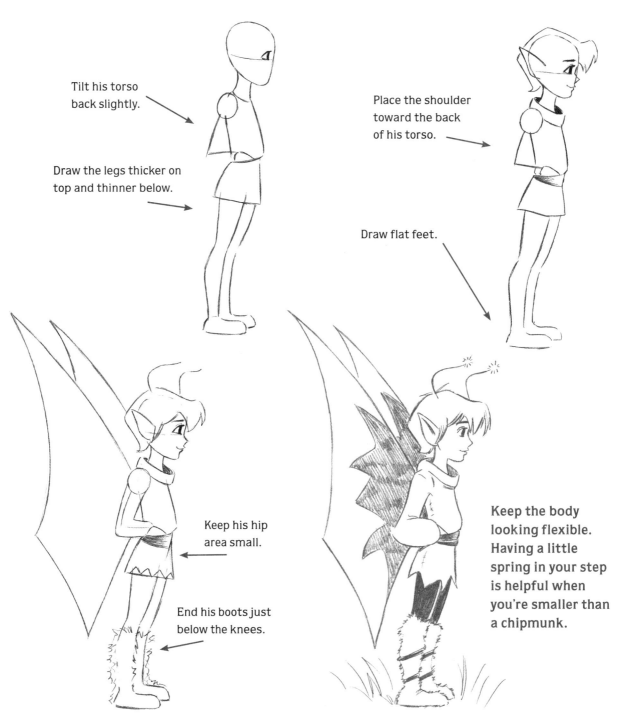

Tilt his torso back slightly.

Draw the legs thicker on top and thinner below.

Place the shoulder toward the back of his torso.

Draw flat feet.

Keep his hip area small.

End his boots just below the knees.

Keep the body looking flexible. Having a little spring in your step is helpful when you're smaller than a chipmunk.

Draw Your Own Pre-Teen Fairy.

Draw the boy fairy's body in a side view. In the side view, be sure to draw both wings—the near one larger and the far one slightly smaller.

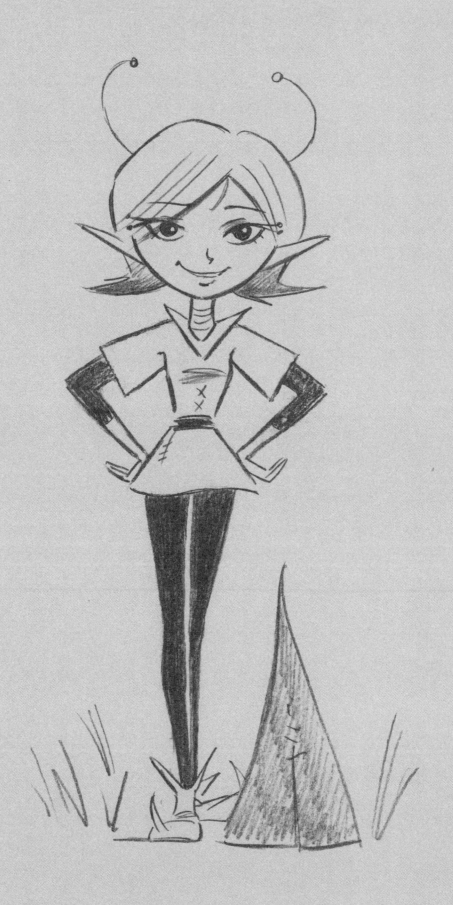

3

Create Magical Clothing and Accessories

I flipped through some popular fairy magazines, like *Fairy Fitness & Fun*, to find insights into what fairies wear. Man, is it tough to read that teensy print; however, using this research material, I've created a virtual catalog of the clothing fairies wear. In this chapter, I've started drawing these fashionable fairies; now you can take over and complete their stylish looks. You can follow my examples or create variations of your own.

Sporty

This fairy got her outfit on sale at a fairy outlet store. It's a one-piece, with a belt and a cute cap. You see a lot of fairies wearing outfits like this one at the spring Ladybug Festival. (Not to be confused with the less popular Larva Festival.) Hurry up and draw her. She can't hold this pose forever.

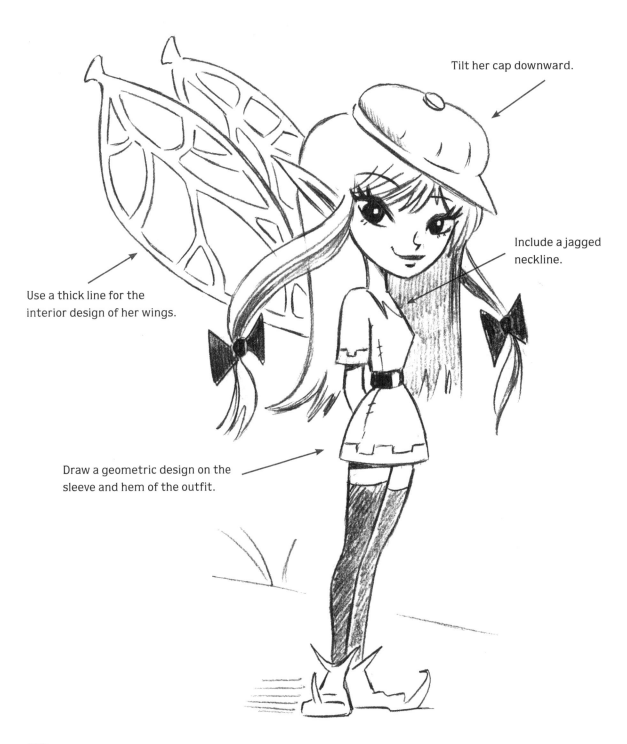

Tilt her cap downward.

Include a jagged neckline.

Use a thick line for the interior design of her wings.

Draw a geometric design on the sleeve and hem of the outfit.

Dress Up This Springtime Fairy.

Draw the pigtails as if they were being pulled apart by magnets. Coloring hint: leave the thick lines of the wings white, and fill in the spaces in between with color.

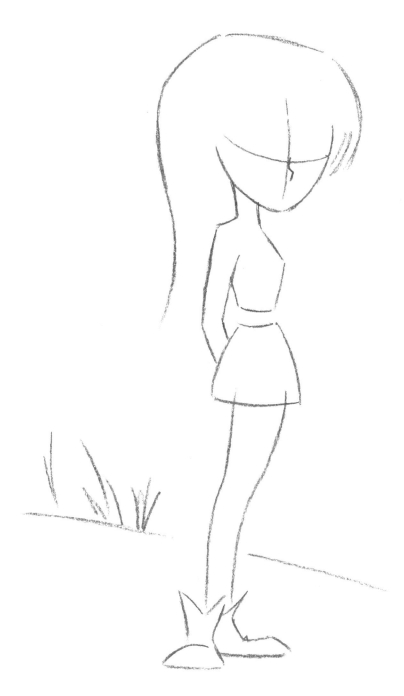

Mod

Now, here's a spiffy look. All the Fairy Boomers are into it. For extra kitsch, this outfit comes with a pair of snap-in-place antennae. Other notable aspects of this look are the sci-fi-style collar and flared skirt. Have fun finishing this cool character.

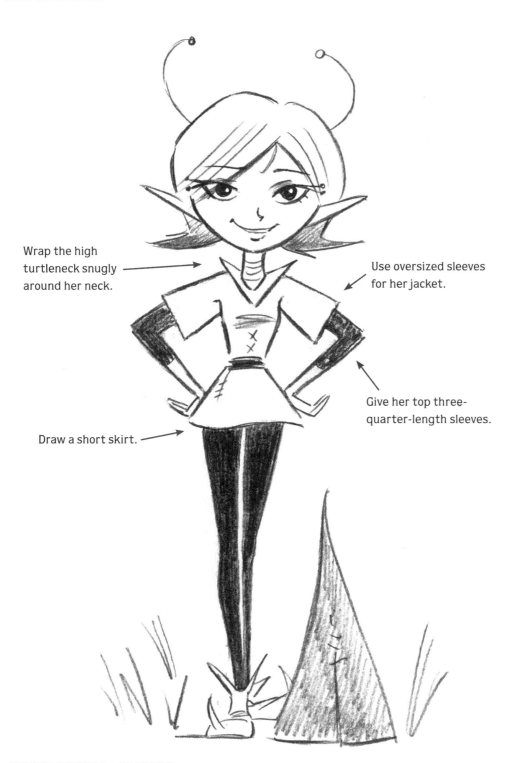

Wrap the high turtleneck snugly around her neck.

Use oversized sleeves for her jacket.

Give her top three-quarter-length sleeves.

Draw a short skirt.

Dress Up This Pop Fairy.

By using a lot of dark areas and white areas, you create eye-catching contrast. All-black leggings are a good option.

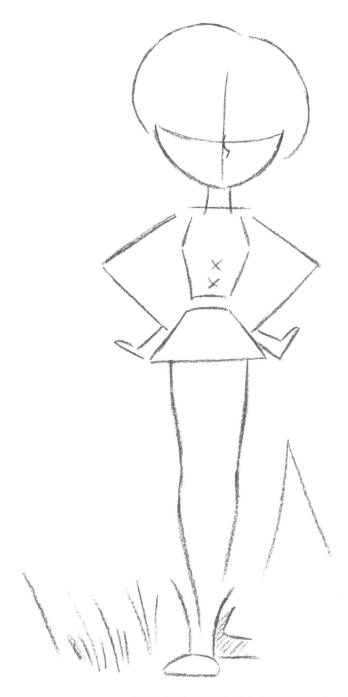

Formal

If you're invited to a fairy ball, you need something special to wear. These dresses come in a variety of types and sizes; however, the most important thing to remember when selecting a gown is to choose the one that drives all the other ladies out of their minds with jealousy.

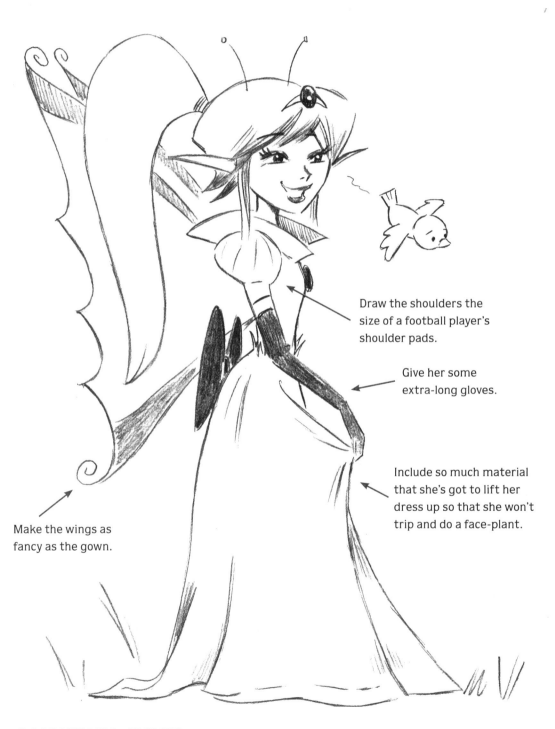

Draw the shoulders the size of a football player's shoulder pads.

Give her some extra-long gloves.

Include so much material that she's got to lift her dress up so that she won't trip and do a face-plant.

Make the wings as fancy as the gown.

Dress Up This Over-the-Top Fairy.

Remember these basic elements of a fairy gown: high waistline, puffy shoulders, oversized skirt, and a bow the size of Rhode Island.

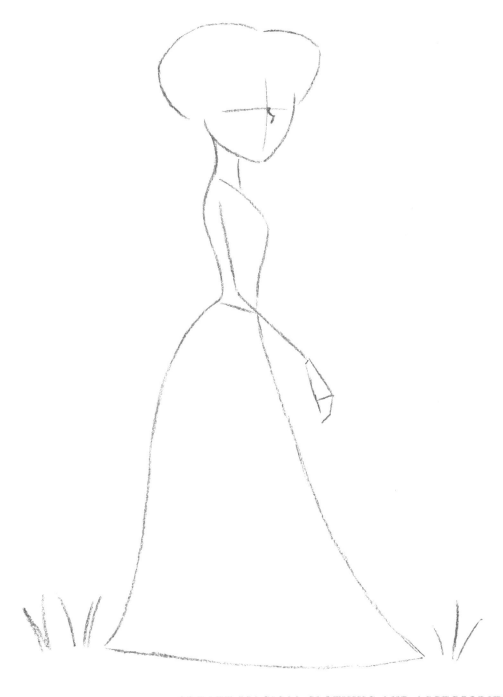

Snow Dress

The fur-lined dress isn't just for gnomes and elves anymore. It's a cool look that everyone can wear—including fairies. The trim is essential to the look. Draw it bumpy—like small clouds. Do you like her fuzzy hat? She borrowed it from her sister. And refuses to give it back.

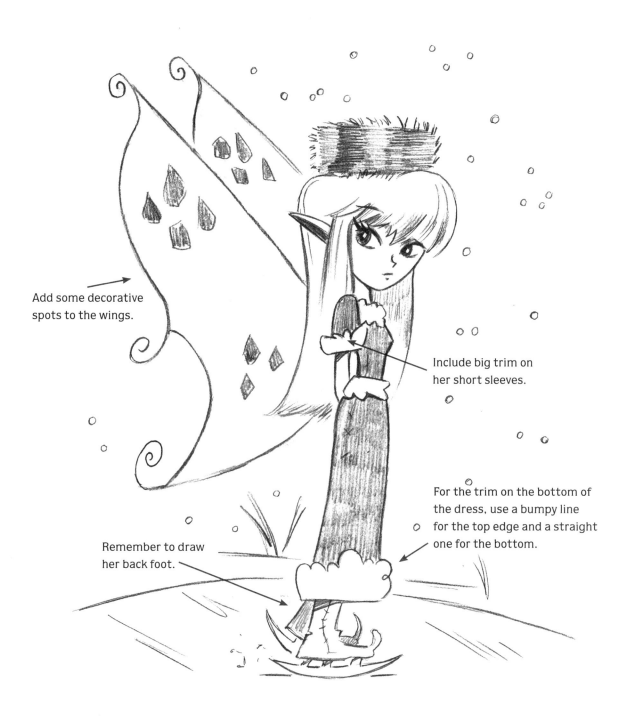

Add some decorative spots to the wings.

Include big trim on her short sleeves.

For the trim on the bottom of the dress, use a bumpy line for the top edge and a straight one for the bottom.

Remember to draw her back foot.

Dress Up This Wintertime Fairy.

You can create a variation of this fairy. How about giving her a scarf, long sleeves, and a knit hat with a pom-pom instead?

The Woodland Look

This shaggy garment is sleeveless and soft. If you want something easy to wear, you can't go wrong with a top and bottom made of fibrous material from the woods. If you see a fairy who looks as if she is clearing shoots and shrubs from a path, she's probably just shopping. Draw this fairy's cute clothing.

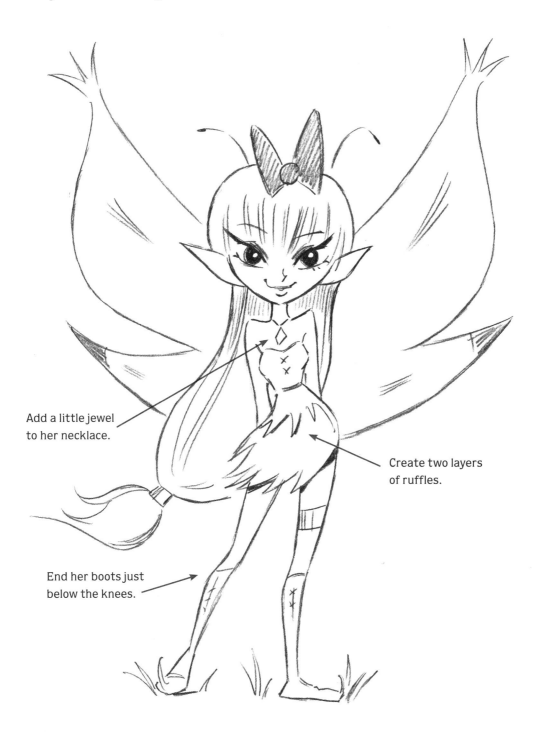

Add a little jewel to her necklace.

Create two layers of ruffles.

End her boots just below the knees.

Dress Up This Forest-Dwelling Fairy.

The wings on this little being are quite tall—reaching high above her head. They've got to be 2, maybe even 3 inches high. No, I'm not exaggerating. Her body leans to the right, and her hair sways to the left.

Nocturnal

This gothic-style fairy is taking her pet out to get a little moonlight. If you sleep all day and are up all night, that means you're either a nocturnal fairy or an average human teenager. Her outfit is a combination of varied elements: mesh stockings; a short, black skirt; and elbow-length gloves.

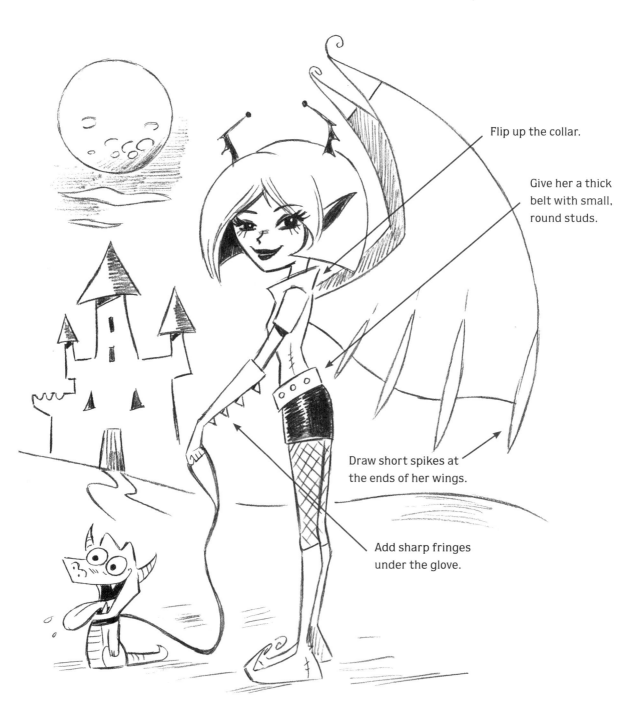

Flip up the collar.

Give her a thick belt with small, round studs.

Draw short spikes at the ends of her wings.

Add sharp fringes under the glove.

Dress Up This Spooky Fairy.

This fairy's style is eclectic—it consists of a lot of different elements. The two elements that are part of a set are the gloves and boots. But why am I wasting my breath? I know the only thing that's on your mind: *Where can I get a little monster like that one?*

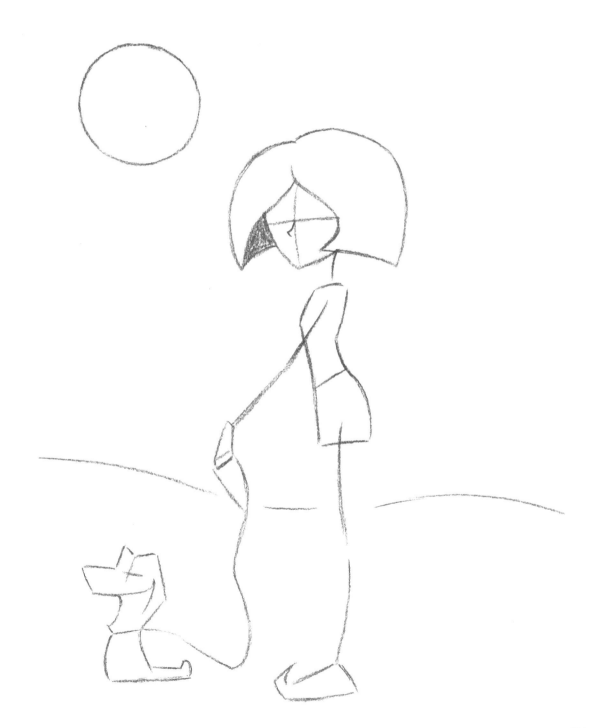

Magical Hats

Fairies wear hats for all sorts of reasons. One, because they look appealing. Two, for special occasions. And three, because they give those who wear them special powers.

Snow Hat

When it's chilly outside, this is the hat you want to wear. It has special slots on the sides for the fairy's large ears. It's made out of moss. (Okay, it's not exactly cashmere, but it works.)

Add buttons and baubles to the peak of the cap.

Draw the hat thick on top and taper it toward the strap on the bottom.

Fuzz it up.

Be sure to show a ribbon under the chin with a knot tied in it.

Magical Cone

This hat is like an upside-down cone, but instead of a scoop of ice cream inside, it's got a scoop of fairy head. Satin is draped down from the tip of the hat. I wonder how she got that star to balance so perfectly on the tip of her cap.

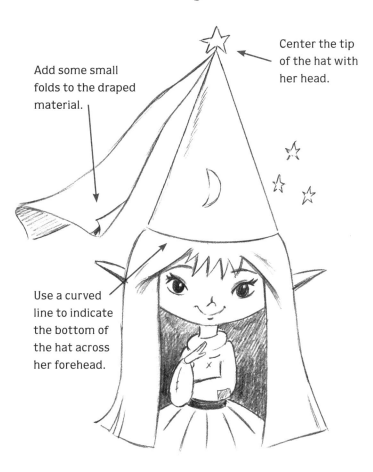

Add some small folds to the draped material.

Center the tip of the hat with her head.

Use a curved line to indicate the bottom of the hat across her forehead.

The base of the hat should be as wide as the head.

Short Hat

Smaller fairy hats are great for going on trips or attending events, such as the annual Kumquat Convention in the meadow. Since it's an all-day affair, these fairies don't want to carry around bulky hats. This sporty model is the perfect answer.

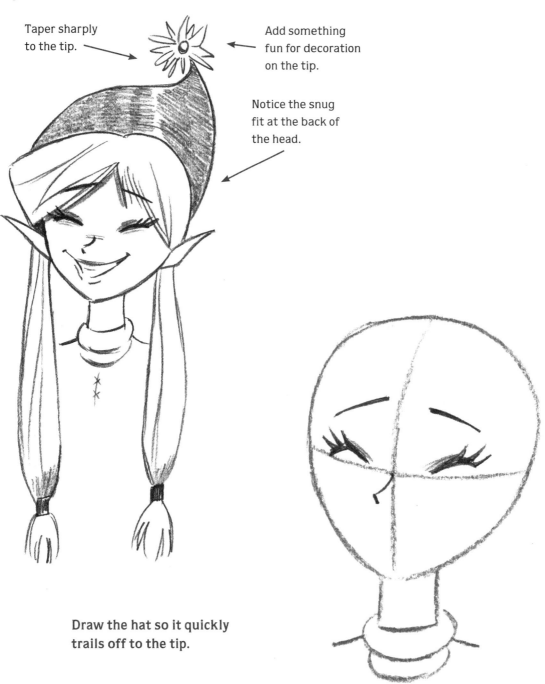

Taper sharply to the tip.

Add something fun for decoration on the tip.

Notice the snug fit at the back of the head.

Draw the hat so it quickly trails off to the tip.

Tulip Hat

You can create fairy hats from all sorts of things. One of the most popular materials is a flower. Lots of different flowers work. But not dandelions. One good breeze and the hat is gone.

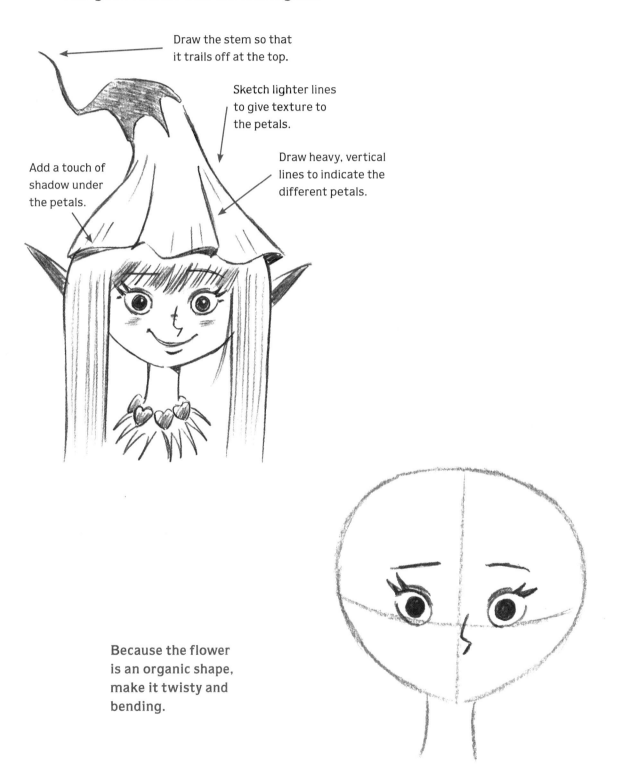

Draw the stem so that it trails off at the top.

Sketch lighter lines to give texture to the petals.

Draw heavy, vertical lines to indicate the different petals.

Add a touch of shadow under the petals.

Because the flower is an organic shape, make it twisty and bending.

Droopy

Hats reflect the emotional state of a fairy. Take this hat for example: its positioning clearly indicates this fairy's mood. This is why fairies never wear hats to poker games.

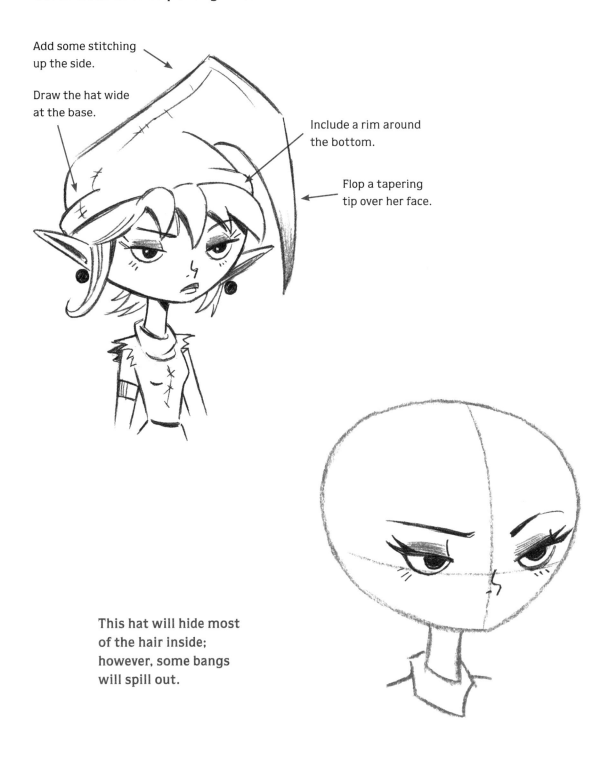

Add some stitching up the side.

Draw the hat wide at the base.

Include a rim around the bottom.

Flop a tapering tip over her face.

This hat will hide most of the hair inside; however, some bangs will spill out.

Wide Brim

Wide brims are great for drizzly mornings. They also provide a superb growing surface for flowers and weeds. The downside is that it's weird for fairies to have to mow their hats.

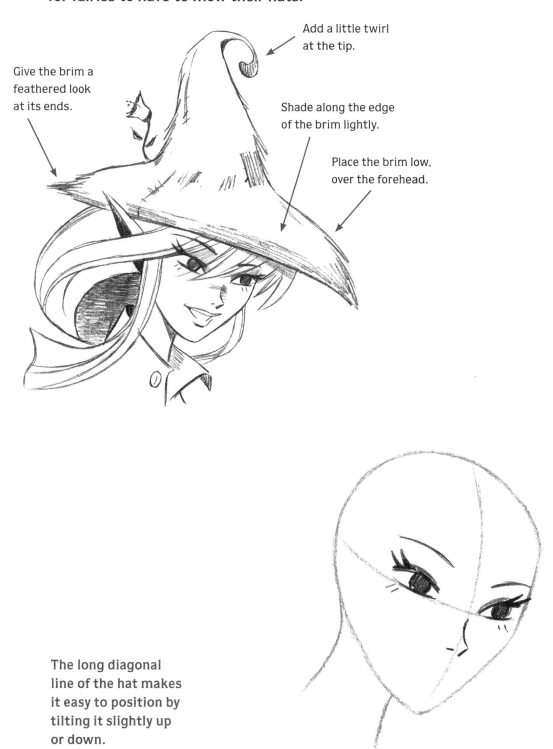

Add a little twirl at the tip.

Give the brim a feathered look at its ends.

Shade along the edge of the brim lightly.

Place the brim low, over the forehead.

The long diagonal line of the hat makes it easy to position by tilting it slightly up or down.

Daisy Crazy

When you see a fairy wearing a ring of daisies, begonias, or snapdragons, it usually means one thing: your garden is missing a whole lot of flowers!

But it's for a good cause. Look how happy she is. You know what else would make her happy? If you planted a few tulips, too.

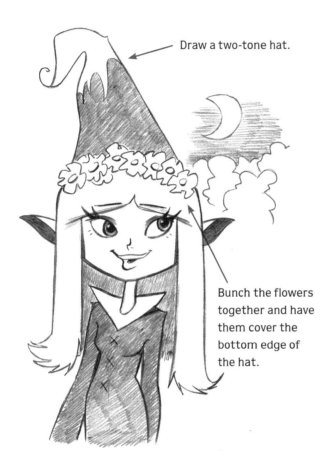

Draw a two-tone hat.

Bunch the flowers together and have them cover the bottom edge of the hat.

First draw the ring of flowers, and then the hat. The flowers are the front layer.

Ring-a-Ding-Ding

Some fairies are very bad with directions and tend to get lost a lot. The "bell hat" is the perfect solution for them. It rings constantly, so everyone knows where the lost fairy is. But no one looks for him, because the constant ringing is so annoying.

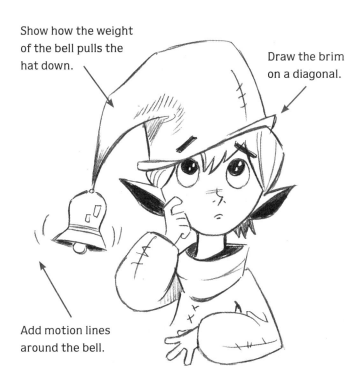

Show how the weight of the bell pulls the hat down.

Draw the brim on a diagonal.

Add motion lines around the bell.

When there is a big doodad on the hat, keep the basic structure simple.

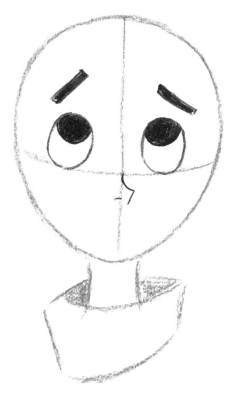

Tiaras

Everyone is familiar with tiaras. They're worn by a third of the kids on Halloween. But have you ever asked where they came from? It was fairies. All I'm saying is that next time you see a tiara on a little kid's head, be sure to tell them, "That was stolen from a fairy."

In the examples that follow, you'll finish drawing a fairy head. Select a tiara from the ones shown or create your own, and draw it onto the finished fairy's head.

Fancy Tiaras

Of course, all tiaras are fancy. But even the fanciest ones come in different styles. Note the massive jewel in the middle.

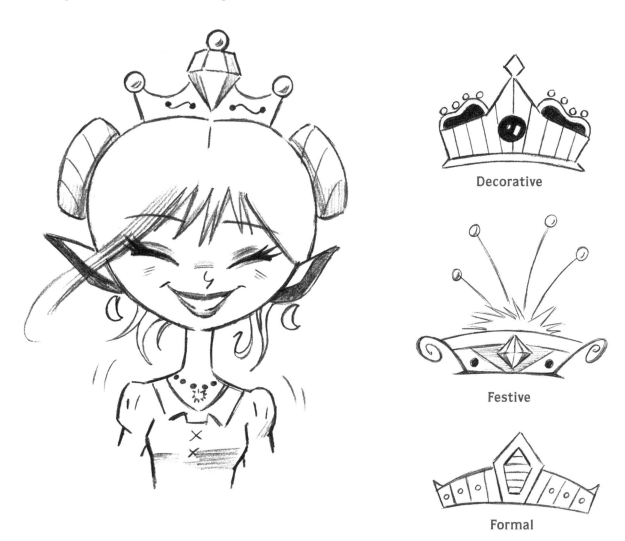

Decorative

Festive

Formal

Pick a Tiara for These Fun-Loving Fairies.

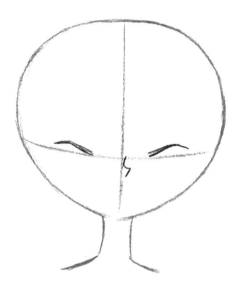

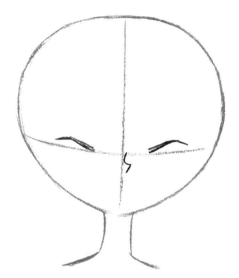

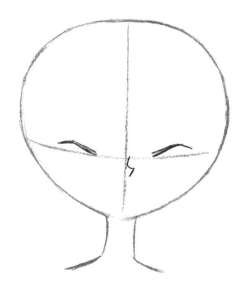

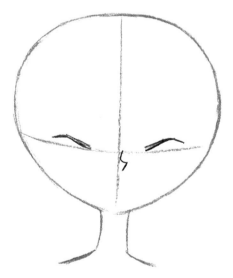

Royal Tiaras

You don't need jewels or symbols of great wealth on a tiara. Any ornate design will work. The shape of the tiara is as important as the design of the interior.

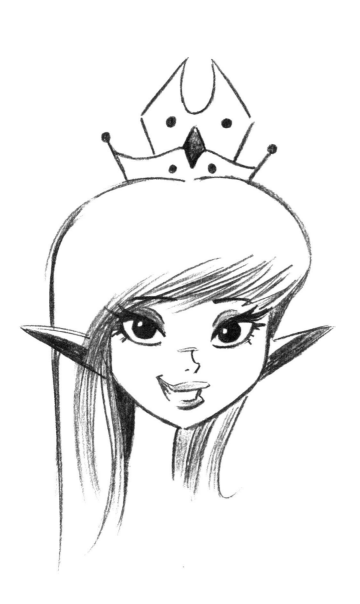

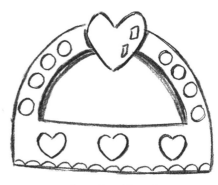
Popping Hearts

Moon

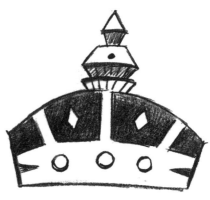
Crown

Pick a Tiara for These Charming Fairies.

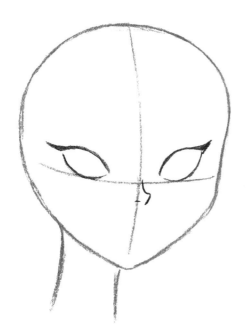

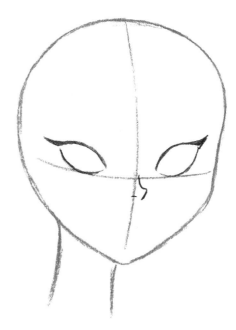

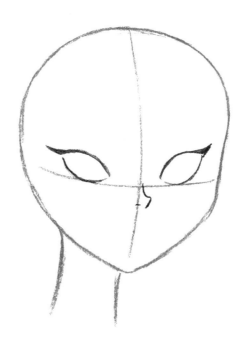

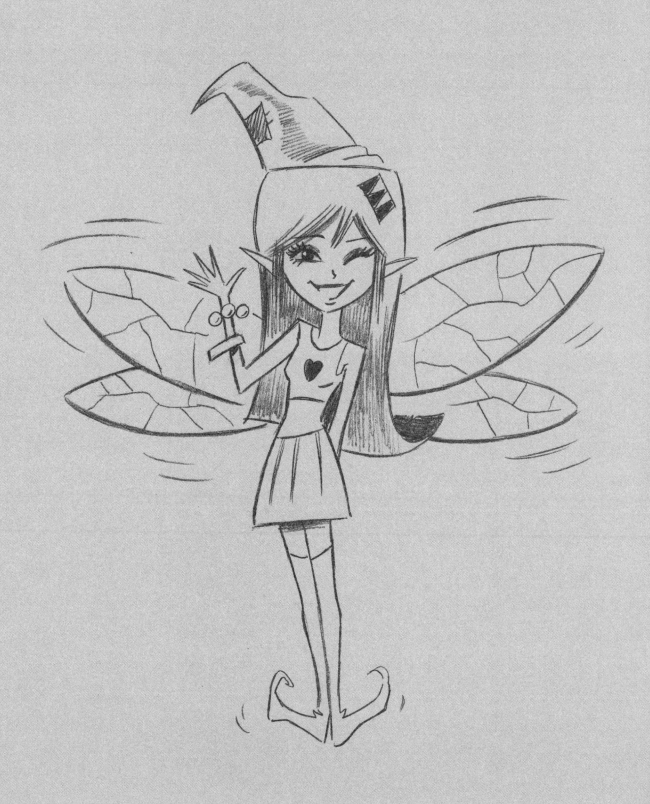

4

Design Fairy Wings and Flying Poses

What is the most defining feature of fairies? Is it their tall hats? Pointed ears? The way they rearrange your keys and glasses so you can't find them? It's actually none of those.

Above all, the things that make fairies fairies are their wings. And that brings me to this chapter, which is all about drawing wings.

There are all sorts of fairy wings. Fancy, casual, magical, wash-and-wear, and more. Pencils ready, fairy fans. Let's begin!

Super-Fancy

These are the wings you would wear for special occasions: a fairy's wedding, the knighting of a fairy, or fairy prom. Super-fancy wings are created from multiple layers. Vary the width and length of the wings to give your drawing a full look.

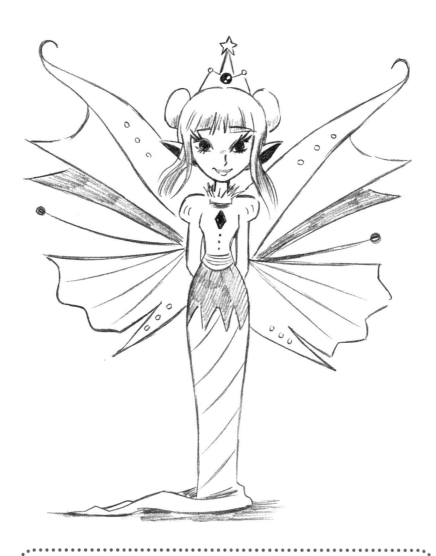

ALTERNATIVE WINGS

Here's a variation for you. It's a simplified version of fancy wings.

Add Wings to This Elegant Fairy.

Complete the face and figure of the fairy. Choose one of the wing types from the opposite page, and draw them on the fairy to complete the character. If you choose the fancier version, draw the upper wing set first, and then the lower wing set.

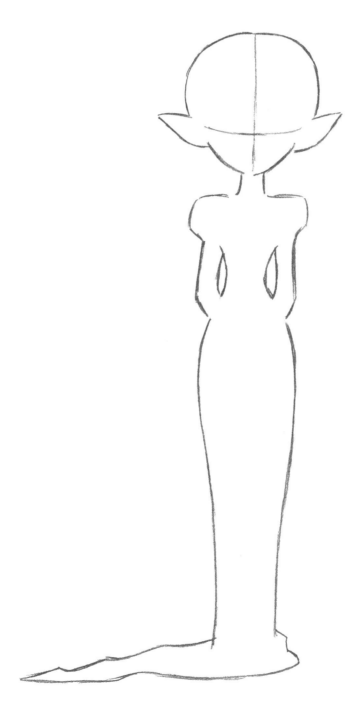

Translucent

To draw translucent wings, add a smattering of random streaks on the wings that are more diagonal or horizontal than vertical. Translucent wings are simple and streamlined for practical use. When not flying, this fairy keeps his wings relaxed, in the "down" position. Since the bottoms of the wings drag along the grass and in the weeds, he has to have them dry-cleaned every few weeks.

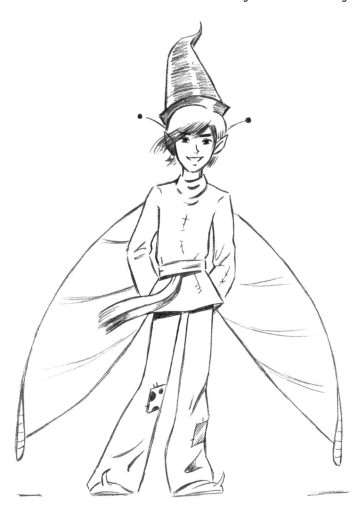

ALTERNATIVE WINGS
Sharply tipped wings are quite sturdy. They're primarily meant for heavy jobs, like hauling a leaf a few feet.

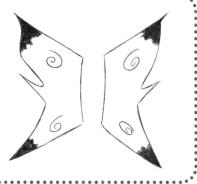

Add Wings to This Woodland Fairy.

Draw the fairy, and then finish with a set of wings from the previous page. The top line of both wings should travel up, and connect to his shoulder blades. His wings, and all wings, must retain a certain degree of width, so they will look like they can do their job.

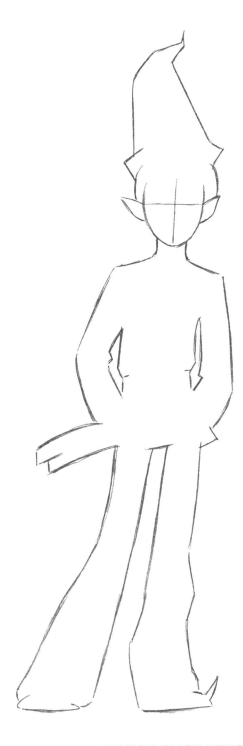

Splashy

This fairy just loves showing off. Some fairies like it when you add glitter to their wings. But one good breeze knocks all of it off. A better approach is to draw irregular designs at the edges of the wings for an energetic look. Notice that the wings are thicker at the tips, giving them stability during flight. Unfortunately, it also makes it difficult to get them through doorways.

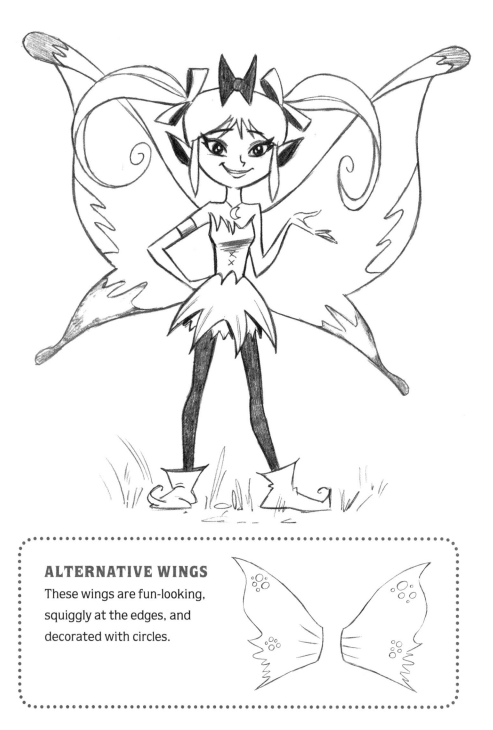

ALTERNATIVE WINGS
These wings are fun-looking, squiggly at the edges, and decorated with circles.

Add Wings to This Bubbly Fairy.

Draw the head, body, and outfit, and then complete the image with large wings in the style of your choosing. Twist the ridge over at the top of the wings for a good look, which also adds depth.

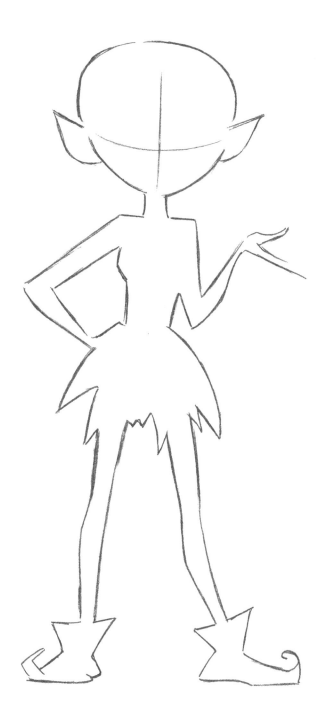

Double Wings

Double wings are fast. Unfortunately, they don't brake so well, as evidenced by an occasional "thud" sound heard near trees. Draw delicate, random, and uneven threads sprouting throughout each wing.

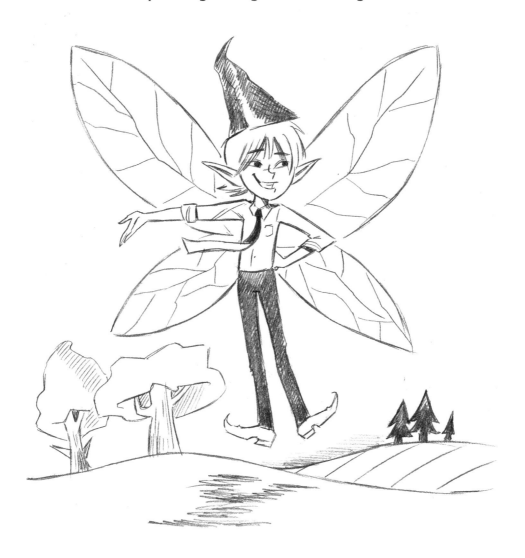

ALTERNATIVE WINGS

In this version of double wings, the upper and lower sections meld into each other. This construction maintains superior aerodynamics, while adding an element of style. The tip of each wing features a downward twirl.

Add Wings to This Show-Off Fairy.

Draw the rest of this perky fairy, and give him a set of wings to show how he remains aloft. For a simple variation, you can draw the wings exactly as you see them on the previous page, but instead of the ultra-thin lines inside, add your own patterns or designs.

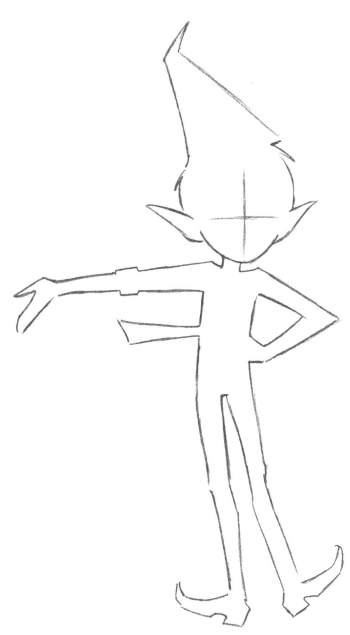

Feathered

Great-looking wings like these don't come without risks. Birds resent them. You can often hear them saying, "Those are ours. We came up with those!" I understand. How would fairies feel if birds wore conical hats? Feather-style wings are quite narrow at the spot where they connect to the back. They also curve in, not out.

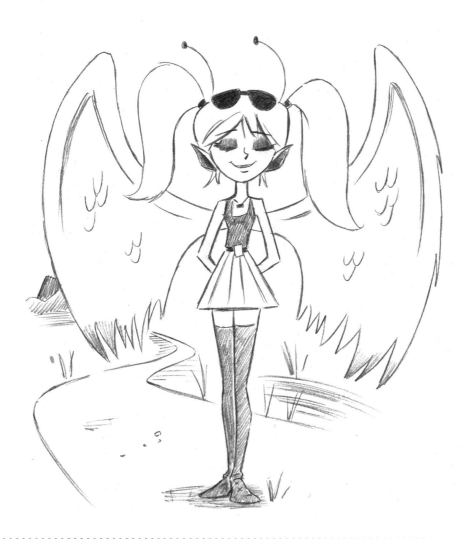

ALTERNATIVE WINGS
Junior-sized feathered wings are shorter than standard wings. The feathers are indicated by two rows, drawn close together.

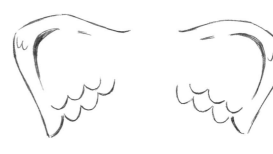

Add Wings to This Cool Fairy.

Draw the wings and complete the rest of the character. These wings put the "span" into the word "wingspan." They are wide when measured side to side. And they clear the body so that they do not overlap with it.

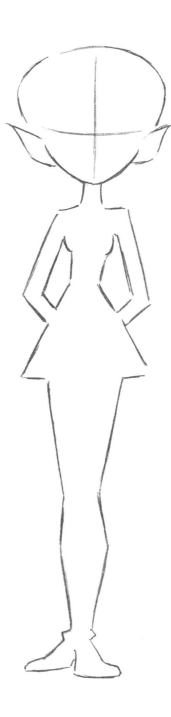

Elegant

Elegant wings are prized throughout the fairy kingdom. What does this fairy do to prevent others from getting jealous? Nothing. Making other fairies jealous is the whole point of having those wings! Technically, these are another type of double wings. The upper set is a different design from the bottom set.

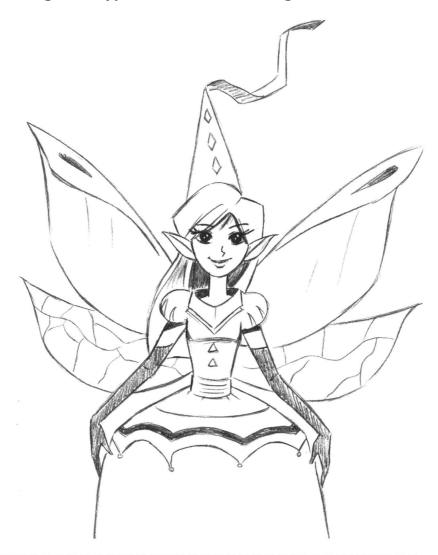

ALTERNATIVE WINGS

A thick ridge creates a cool look. Draw the wings so that they curl away at their tips.

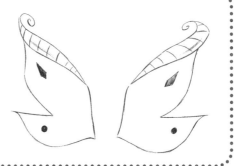

Add Wings to This Welcoming Fairy.

Finish the fairy, and then choose a set of wings or make up your own. These wings may not seem unique at first, but their position is interesting. Both sets of wings are lifted up, which enhances the effect of her cheerful expression.

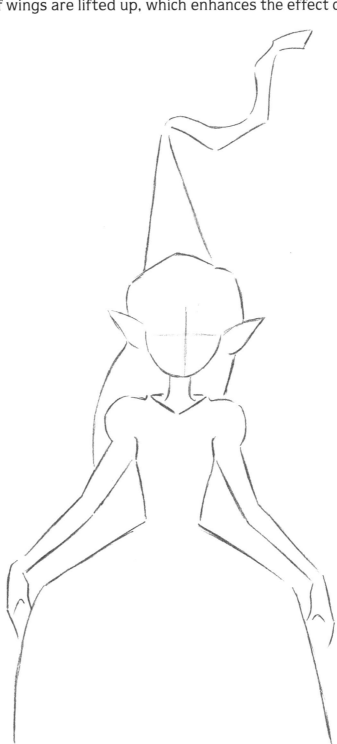

Flying Poses

Fairies learn to fly at a very young age—about five minutes old. Some are clumsy, others graceful. Still others are angry, which can cause "sky rage." But typically, each fairy manages to stay in his or her airstream. Flying poses have to indicate the direction in which the fairy is flying. In this section, I'll start with the basics. On the facing page, you'll complete the drawing.

Soaring

When fairies fly up at a diagonal, they're soaring. When they fly down at a diagonal, they're crashing. It's sort of like doing a cannonball into the grass. In this soaring pose, the fairy stretches out with her back arched.

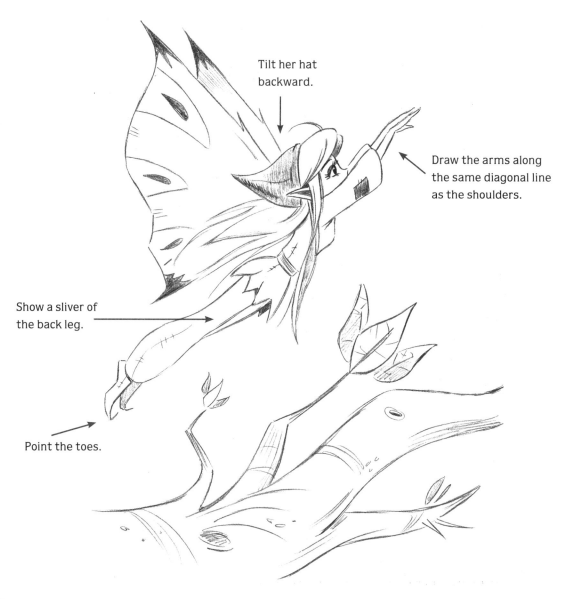

Tilt her hat backward.

Draw the arms along the same diagonal line as the shoulders.

Show a sliver of the back leg.

Point the toes.

Complete the Soaring Pose.

Complete the drawing, and add a few clouds to indicate the altitude.
Arch the back, and duck out of the way of any falling acorns.

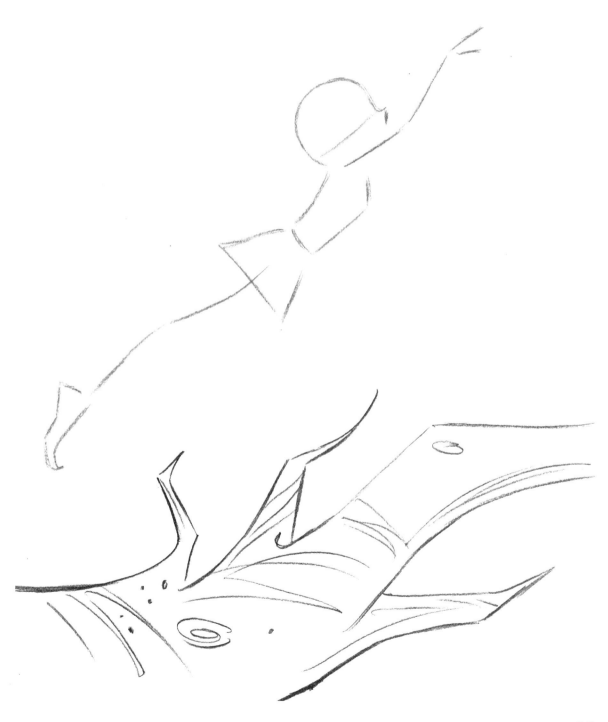

Bee Careful

You can upset the wrong type of critter by flying into its airspace. The takeaway here is: never slow down near a honeycomb. Bees are not making the honey for you. This "arms-out" pose makes the fairy appear as though he is flying fast.

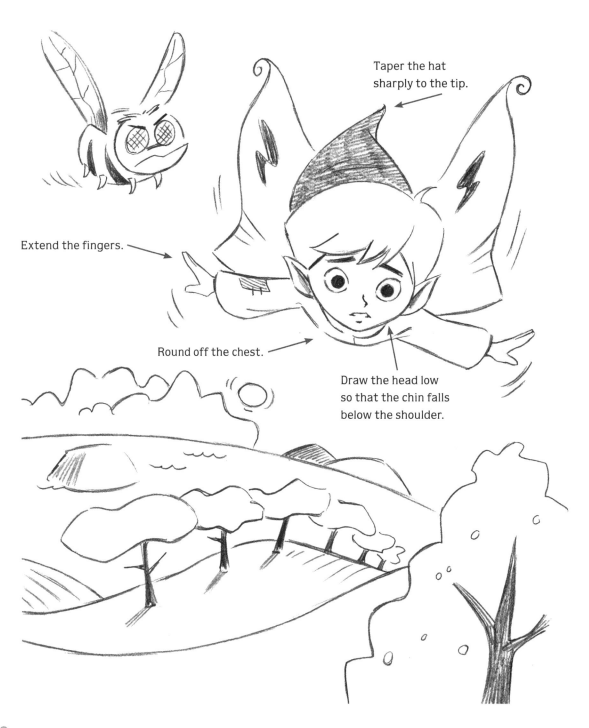

Taper the hat sharply to the tip.

Extend the fingers.

Round off the chest.

Draw the head low so that the chin falls below the shoulder.

Complete This "Yikes!" Pose.

Finish both the bee and the fairy. (Draw his wings way up—in panic mode!)
If you want to take it further, you can also flesh out the background.
The near hillside slopes down, while the horizon line curves up.

Today's Forecast: Windy

Humans check for rain before they go out. Fairies check for wind speed. Unfortunately, some fairies assume that the wind won't be blustery. They lose more hats that way . . .

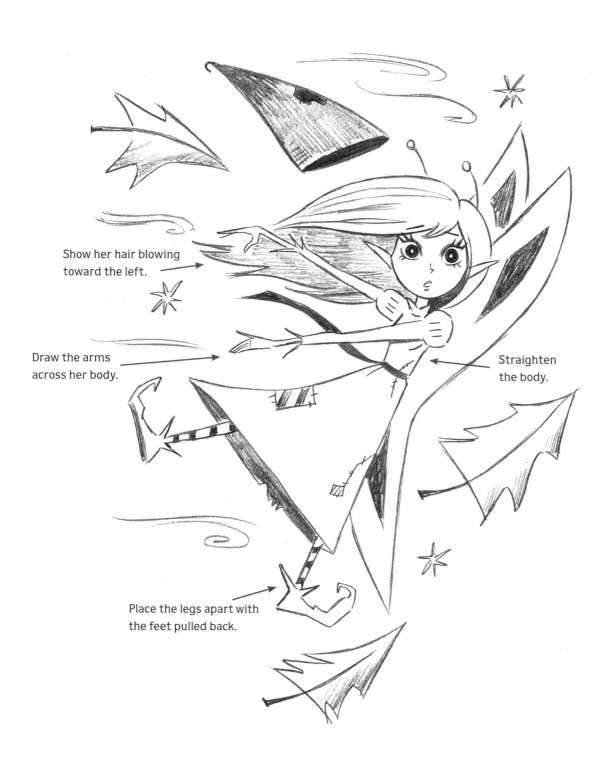

Show her hair blowing toward the left.

Draw the arms across her body.

Straighten the body.

Place the legs apart with the feet pulled back.

Complete This Befuddled Pose.

Draw a surprised look on this fairy's face. Don't forget to draw a bunch of loose, oversized leaves. The thing that makes this pose funny is that it's totally stiff!

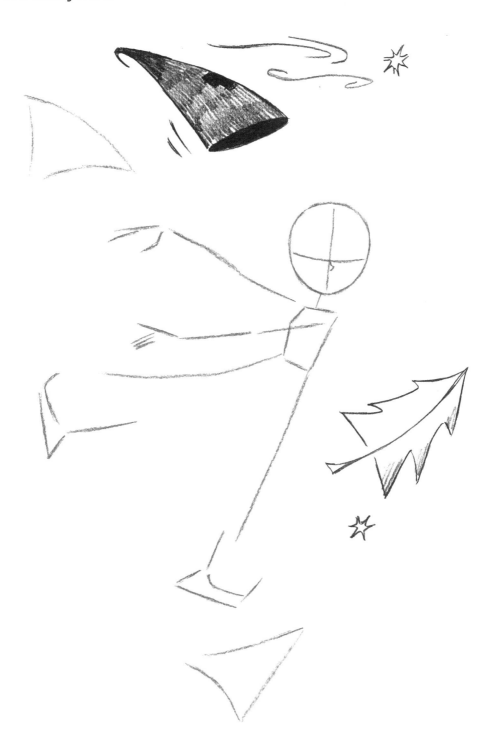

Don't Text and Fly

Like the heading above suggests: don't text when flying. If you have to text, pull over to the shoulder of the air and text from there. This unfortunate fairy has not heeded this advice. As a result, the sound you're about to hear is what happens when one-sixteenth of an ounce of fairy collides with six tons of tree. Draw this fairy in a horizontal position with her cell phone held directly in front of her face.

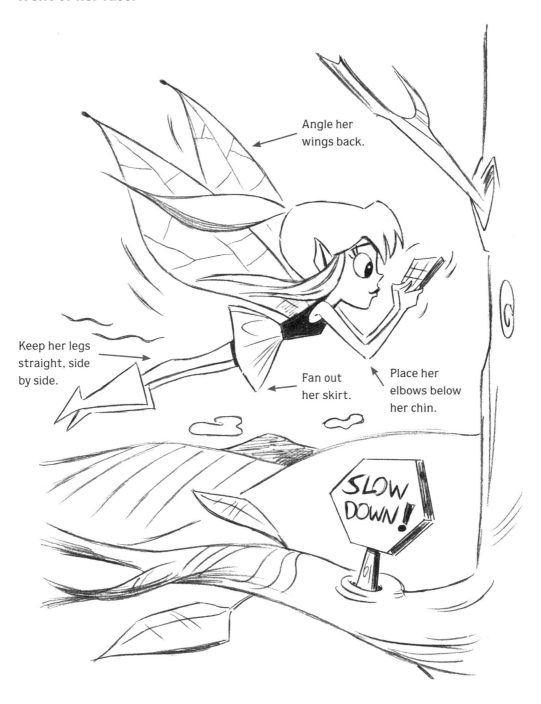

Complete This Oblivious Pose.

When drawing this fairy, make sure the front of her face is vertical. Sketch in the rest of the background. Make sure the cell phone is in front of her eyes so that it blocks the view of the approaching tree.

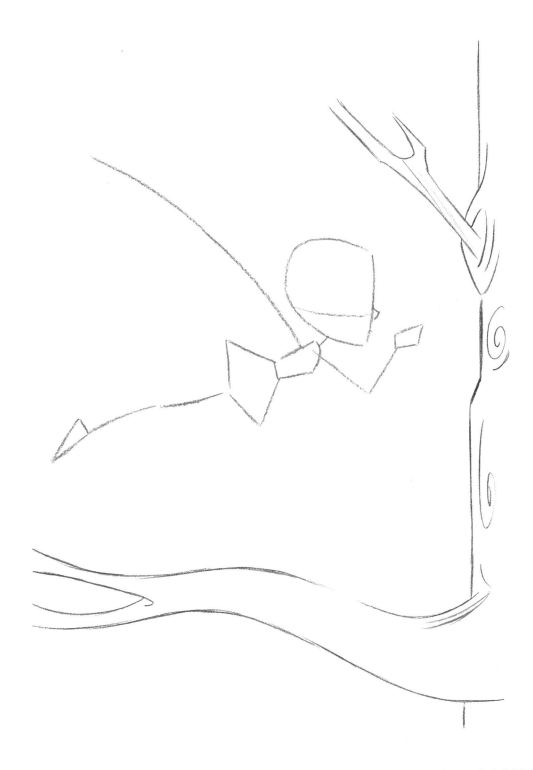

Landing

Since there are no runways in the woods (they'd be too easy for humans to spot), fairies have to find other places on which to make soft landings. Mushroom tops are a perfect alternative. They're spongy and plentiful. The drawback is that you end up smelling like a salad for the rest of the day—no fairy wants to be mistaken for a crouton. The momentum causes the wings to rise up above her head.

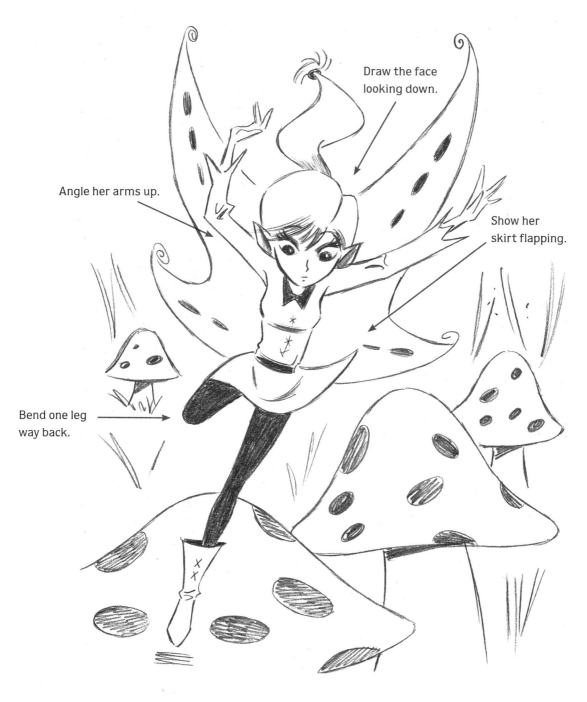

Draw the face looking down.

Angle her arms up.

Show her skirt flapping.

Bend one leg way back.

Complete This Incoming Pose.

Show lots of action by extending her limbs and stretching her torso. Overlap the mushrooms below her.

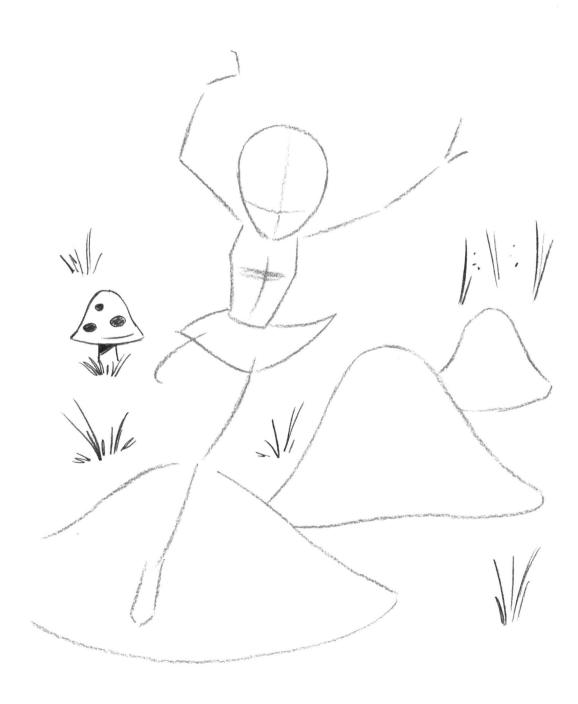

Hovering

Fairies can't contain themselves. When they get happy, they take off. This fairy must like you because she's becoming airborne. Add vibration lines around the wings to make them look as if they're moving rapidly.

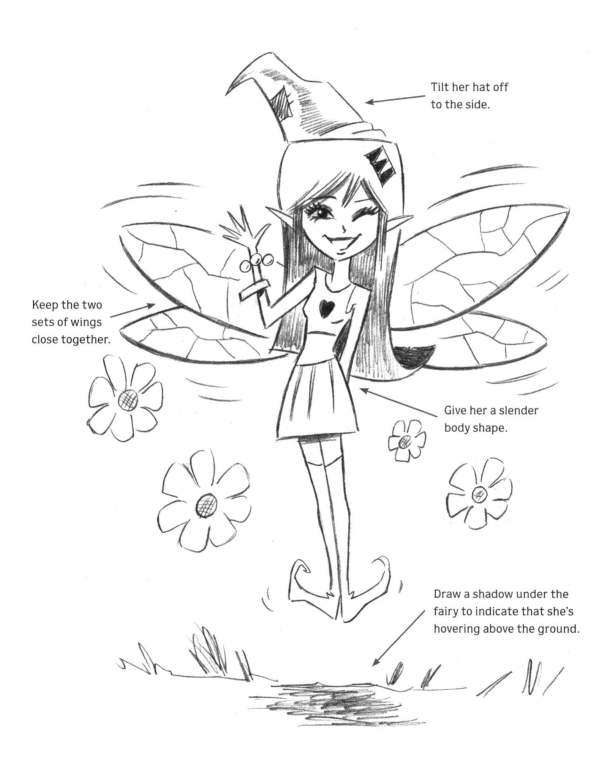

Tilt her hat off to the side.

Keep the two sets of wings close together.

Give her a slender body shape.

Draw a shadow under the fairy to indicate that she's hovering above the ground.

Complete This Floating Pose.

Create your fairy by drawing the character, wings, and decorative flowers. Usually, the wings serve as background—but in this case, they are essential, so draw them with a thick line.

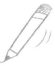

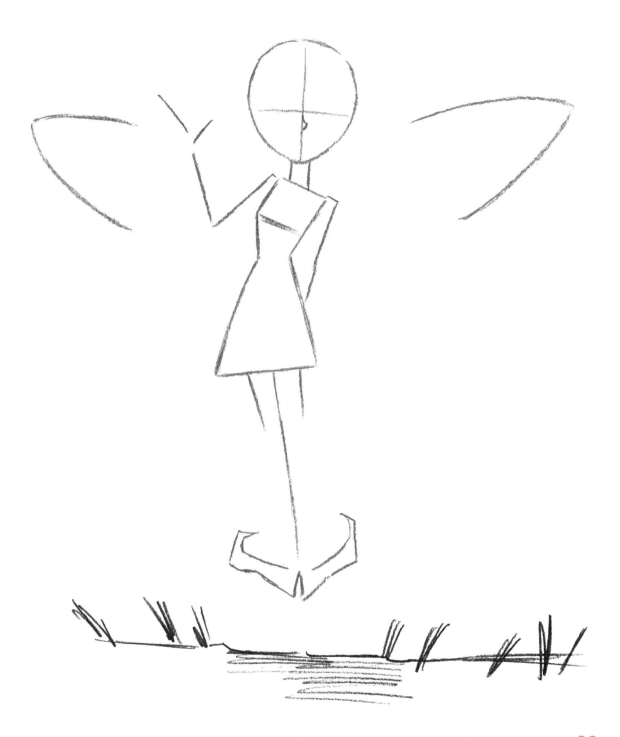

Good Read

A cushy armchair may be comfortable for humans, but for fairies, it really cramps their wings. When they get up, they've got to unfold them and iron them. It's far easier to read while treading air. Draw your airborne fairy reading in a sitting pose, while her wings flutter.

Draw repeated lines of the wings, which will make it appear as if they are fluttering.

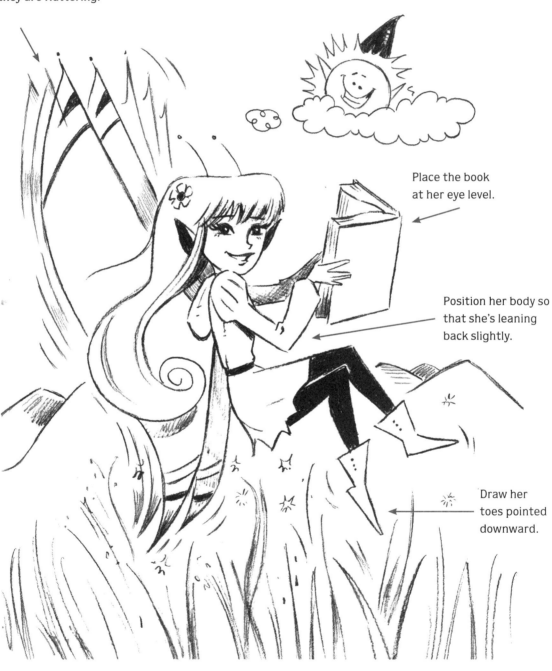

Place the book at her eye level.

Position her body so that she's leaning back slightly.

Draw her toes pointed downward.

Complete This Intellectual Pose.

Draw the features of the face, and fill out the figure. Then draw a long set of wings in back. Use angular knees to make this position work.

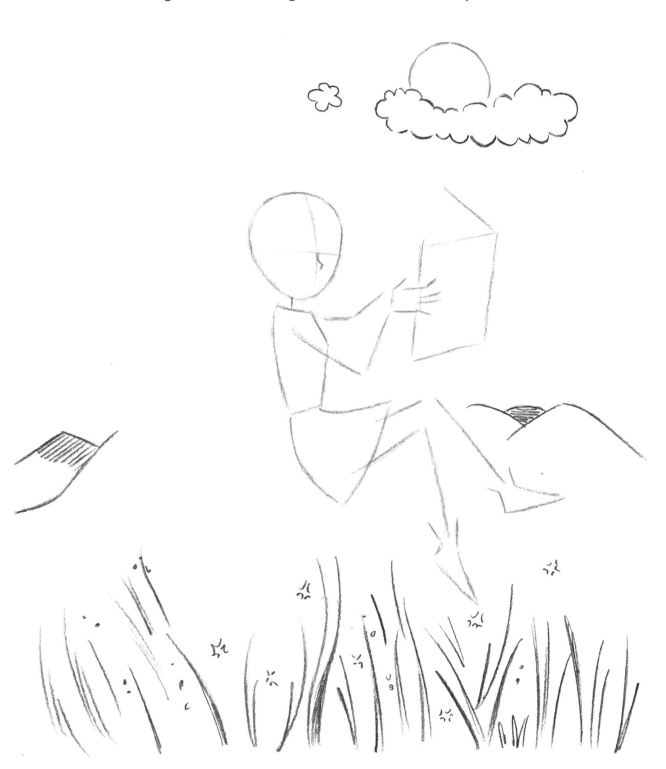

Warrior Stance

Someone has to defend the realm against enemies and lawn mowers. Draw this warrior fairy in a heroic pose. Ever alert, her wings are at the ready. At a moment's notice, she can engage in battle with a spider or a sticky candy wrapper. Her body is drawn in an L shape, which gives her a dramatic appearance.

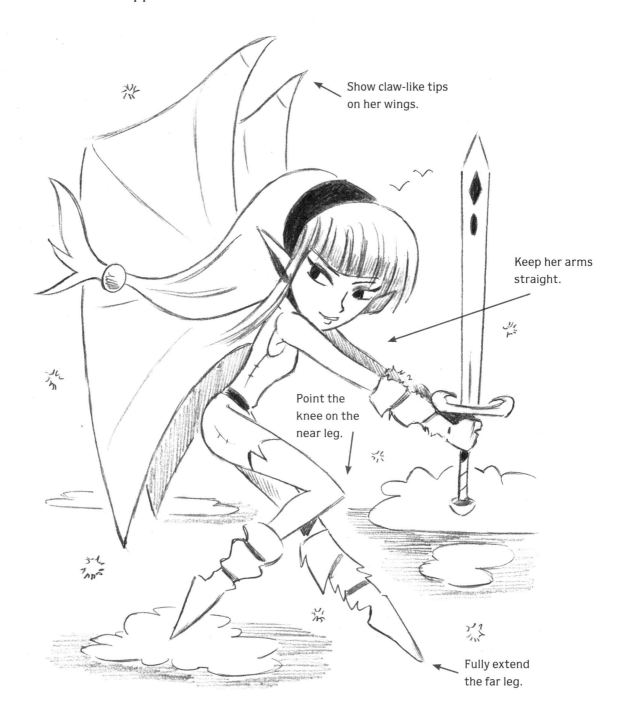

Show claw-like tips on her wings.

Keep her arms straight.

Point the knee on the near leg.

Fully extend the far leg.

Complete This Fierce Pose.

To make a variation, draw a fancy sword, a tiara, or arm and leg bands. Draw the body at an angle—tilting forward. You don't want her to appear static.

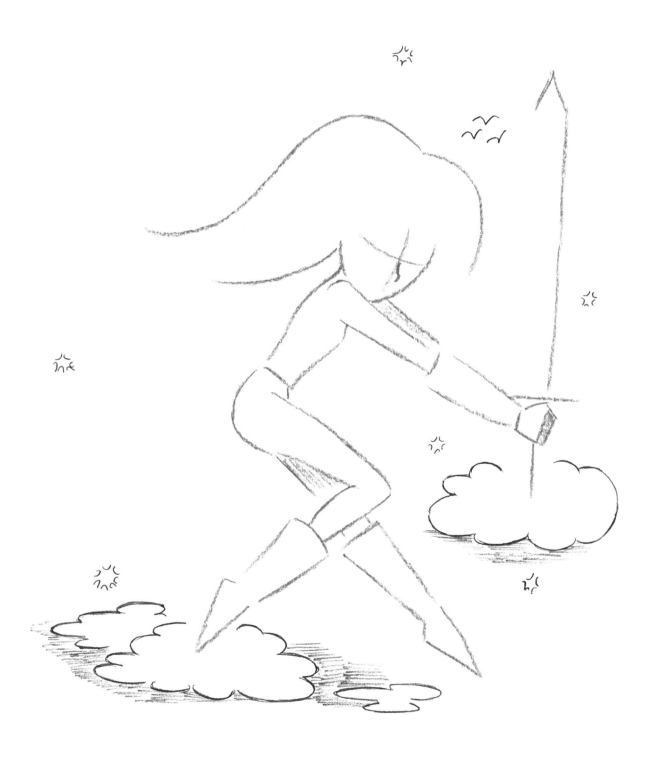

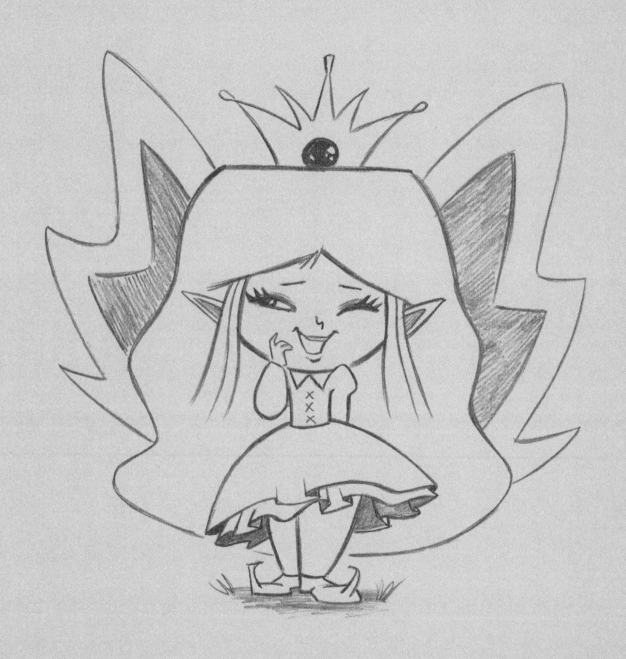

5

Give Your Fairies Personality

There are many types of fairies. There's the nervous type, who sounds the alarm any time a pinecone drops. Then there's the overly friendly type, who attempts to pet raccoons. There aren't too many of that type left. In this chapter, you'll learn how to draw various popular fairy personalities. You'll draw a head shot—as well as a full-figure shot—of each fairy type.

Hopeless Romantic

In spring, flowers bloom, the trees are green, the meadows are full, the entire kingdom is suffering with allergies, and love is in the air.

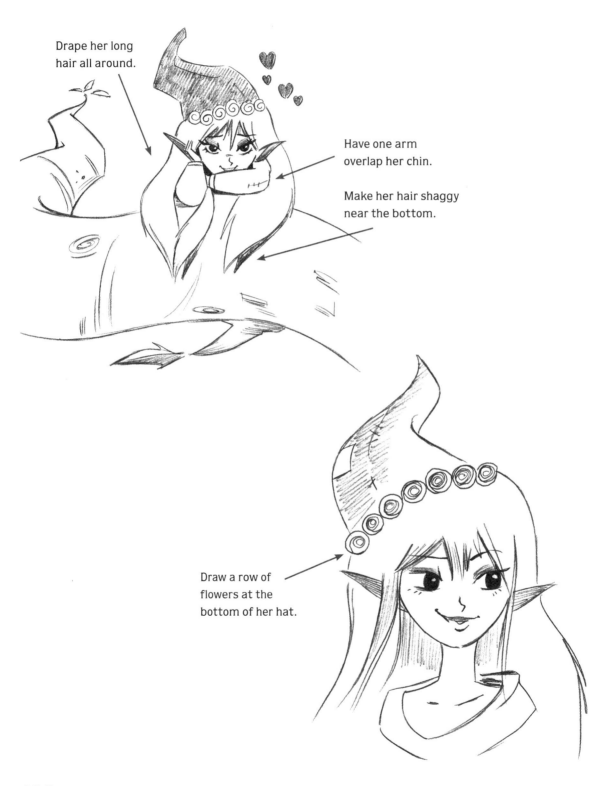

Drape her long hair all around.

Have one arm overlap her chin.

Make her hair shaggy near the bottom.

Draw a row of flowers at the bottom of her hat.

Give This Lovestruck Fairy Some Personality.

The hopeless romantic has a nice smile and big, dreamy eyes. This expression comes from the eyes, so we increase their size, and make the mouth small.

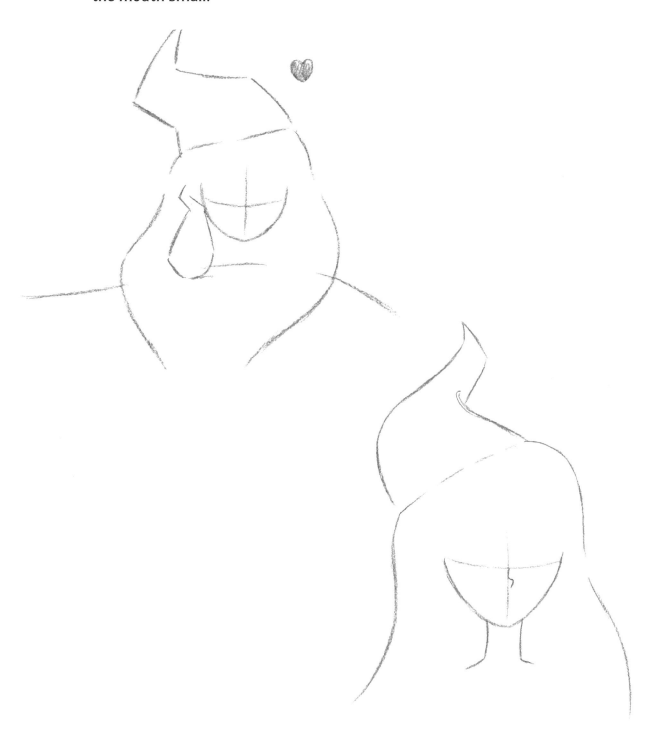

Little Black Cloud

Some people have tried to lift this fairy out of his gloomy mood. In fact, a few weeks ago, a jolly fairy paid him a visit. Instead of cheering him up, the visit resulted in two gloomy fairies. Notice how the wings are in the "down" position. This placement can be used to show a negative attitude. Note the prickly pose. Not exactly an invitation for a hug.

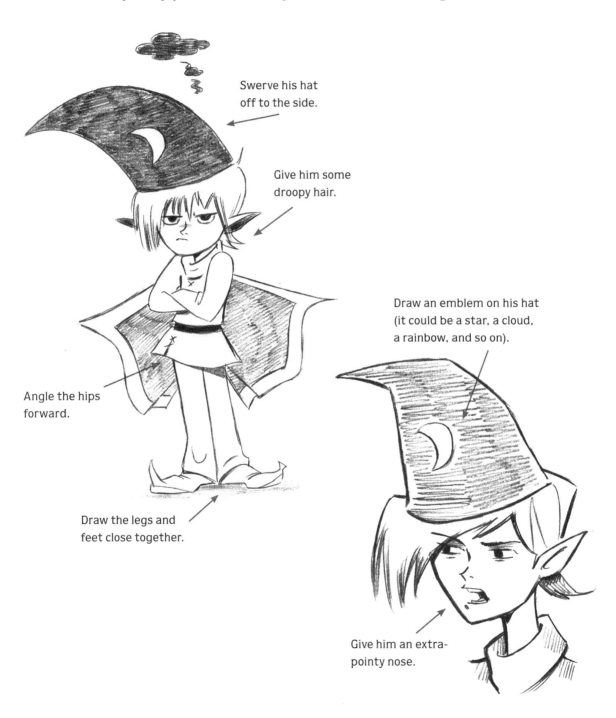

Swerve his hat off to the side.

Give him some droopy hair.

Draw an emblem on his hat (it could be a star, a cloud, a rainbow, and so on).

Angle the hips forward.

Draw the legs and feet close together.

Give him an extra-pointy nose.

Give Mr. Cheerful Some Personality.

This character is all about his own inner dialogue. Therefore, his expression and pose tend to be turned inward.

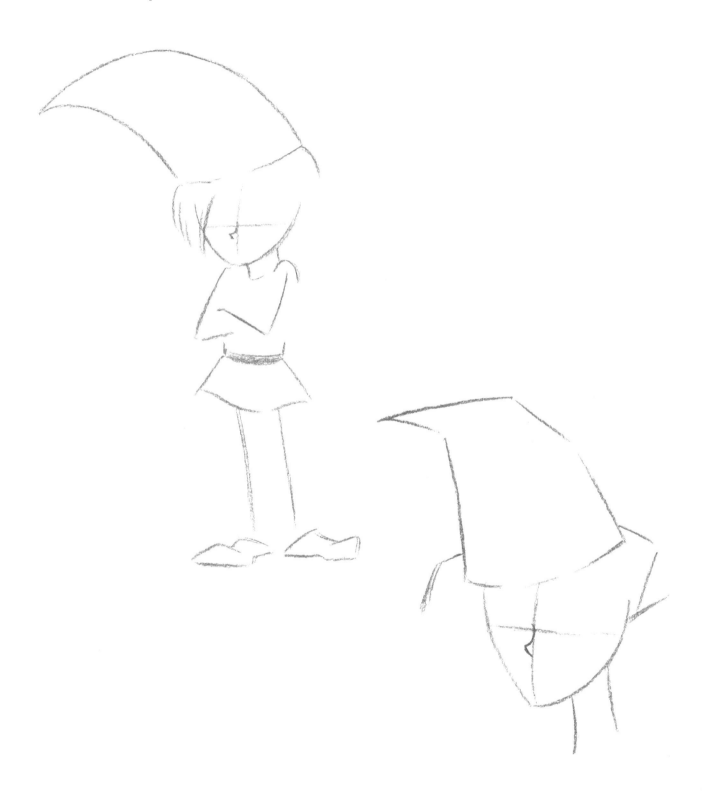

Hates to Share

When this fairy was little, he was taught the importance of sharing. And since that time, he's been "sharing" everybody else's stuff but never his own. Peanuts are his favorite. This type is all about long arms so he can hug his "loot."

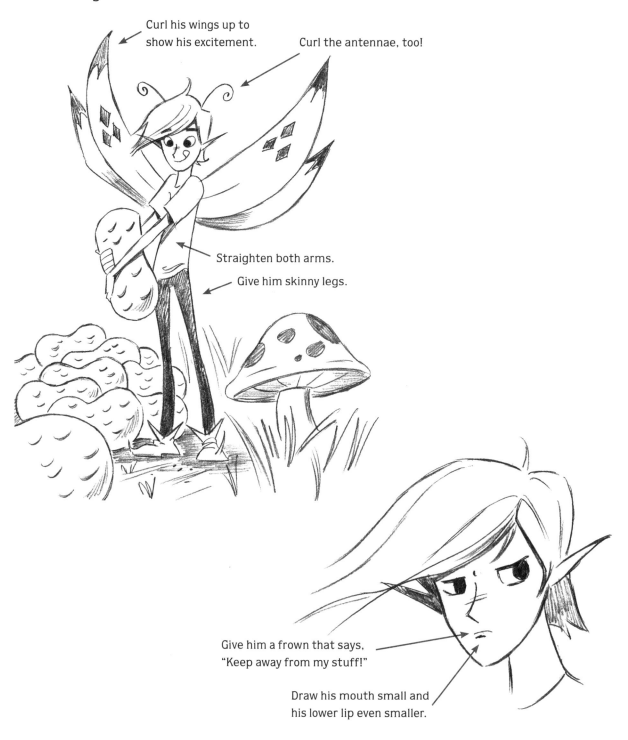

Curl his wings up to show his excitement.

Curl the antennae, too!

Straighten both arms.

Give him skinny legs.

Give him a frown that says, "Keep away from my stuff!"

Draw his mouth small and his lower lip even smaller.

Give This Greedy Fairy Some Personality.

This guy is all about attitude. He's possessive. You can show it in his frame and his raised shoulders.

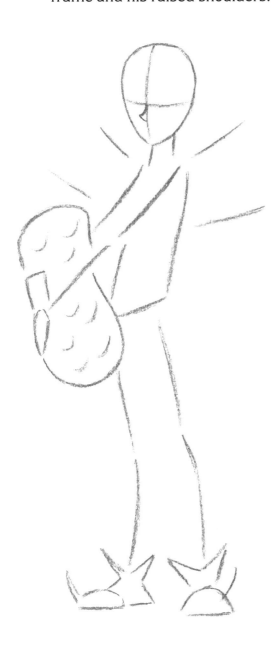

Cute and Little

All fairies are little. But this one is little even for a fairy. Any smaller and she could fit in her own pocket.

Her head is wider than her body—by a lot. She also wears a skirt over loose-fitting fairy pants and small shoes.

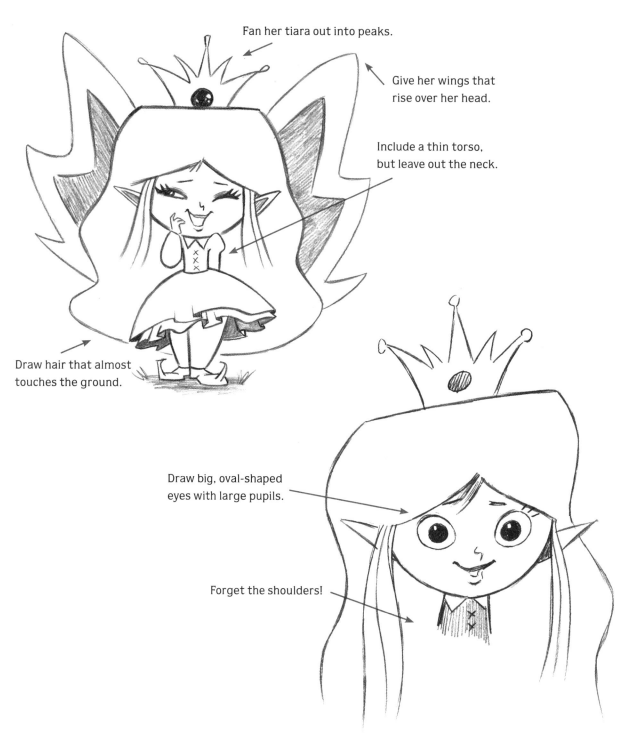

Fan her tiara out into peaks.

Give her wings that rise over her head.

Include a thin torso, but leave out the neck.

Draw hair that almost touches the ground.

Draw big, oval-shaped eyes with large pupils.

Forget the shoulders!

Give This Precocious Fairy Some Personality.

Draw this cute magical being with simple strokes. Don't complicate cuteness—that's rule #65 in the official fairy manual.

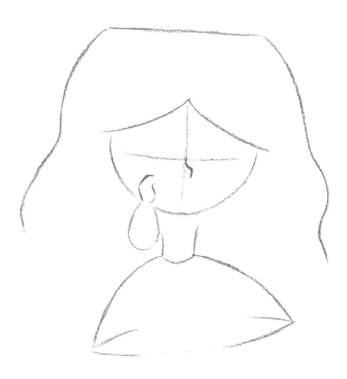

Way Wicked

You may never have actually seen an evil fairy, but you have seen their effects. Why do you think a slice of bread always falls jelly-side-down? Evil fairy. Why can you never find your glasses? Evil fairy.

Draw the evil fairy with claws on the tips of her wings. Tilt her hat forward in an assertive position. Give her thin lips and gritted teeth.

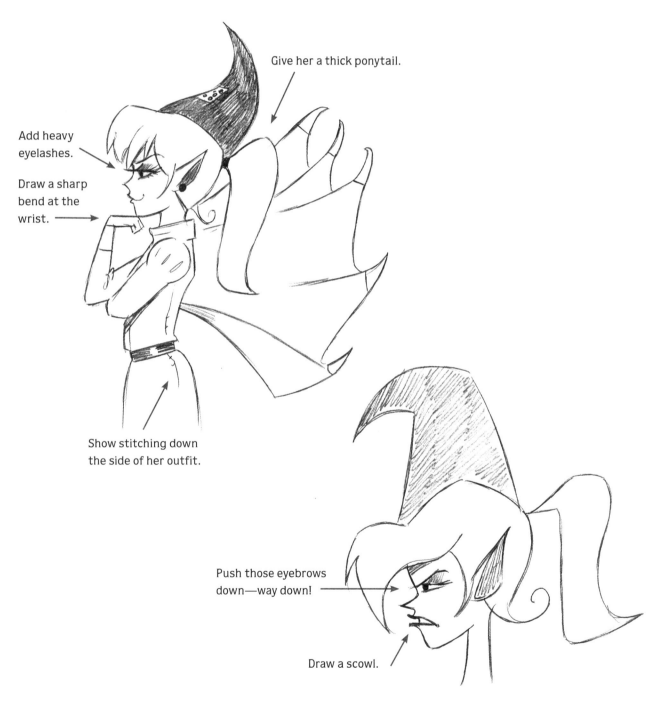

Give her a thick ponytail.

Add heavy eyelashes.

Draw a sharp bend at the wrist.

Show stitching down the side of her outfit.

Push those eyebrows down—way down!

Draw a scowl.

Give This Malevolent Fairy Some Personality.

Wicked characters drip with evil. So by all means, overdo it! Have fun!

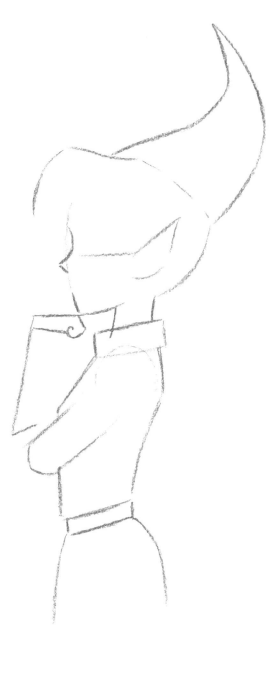

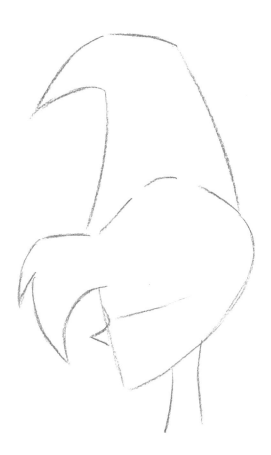

An Absolute Angel

This fairy can do no wrong. When he sees litter on the ground, he picks it up. If someone walks against a red light, he will gently admonish them. If someone tries to rip the tag off a mattress, he'll alert the authorities. No wonder he has no friends.

Give this angelic type a slight build, with an oversized head and big, wide-open eyes.

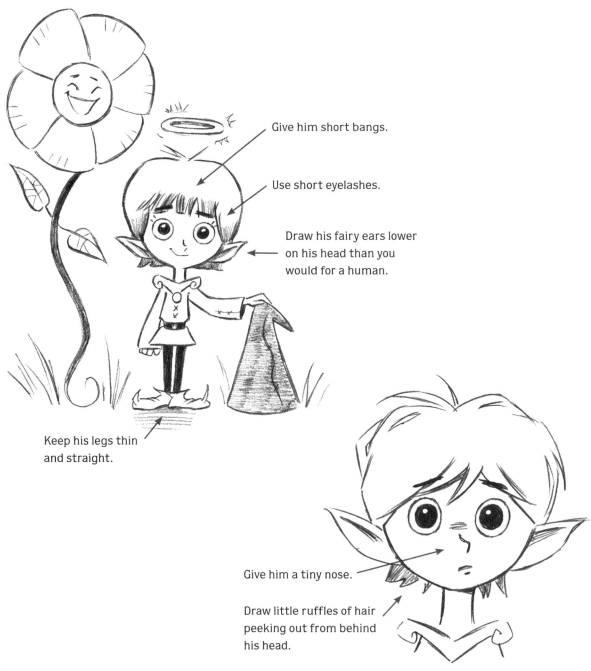

Give him short bangs.

Use short eyelashes.

Draw his fairy ears lower on his head than you would for a human.

Keep his legs thin and straight.

Give him a tiny nose.

Draw little ruffles of hair peeking out from behind his head.

Give This Goody-Two-Shoes Fairy Some Personality.

Look at those giant pupils. He's either a complete angel, or he's just returned from an eye exam.

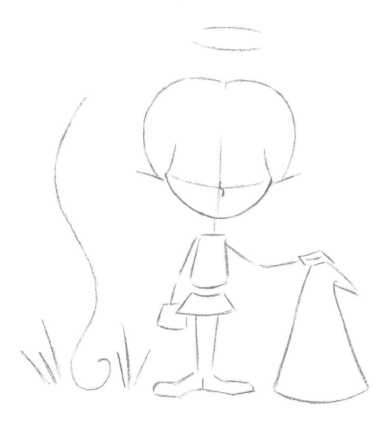

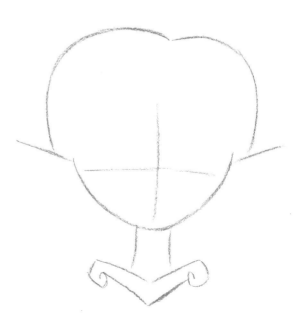

Easily Hurt

Was it something you said? Actually, it was anything you said, or ever will say! This sensitive fairy has her feelings hurt easily. If it rains, she takes it personally.

Point her nose up slightly and pout those lips. Notice that her antennae are pointed ahead, as if they have turned their backs, too.

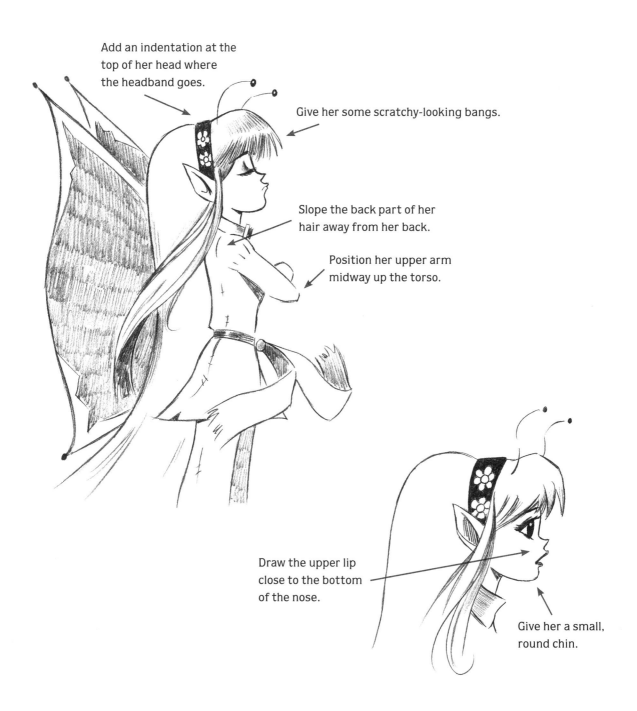

Add an indentation at the top of her head where the headband goes.

Give her some scratchy-looking bangs.

Slope the back part of her hair away from her back.

Position her upper arm midway up the torso.

Draw the upper lip close to the bottom of the nose.

Give her a small, round chin.

Give This Sensitive Fairy Some Personality.

Pouty lips and a stiff spine are all you need to portray a fairy seeking an apology from every mammal in the woods.

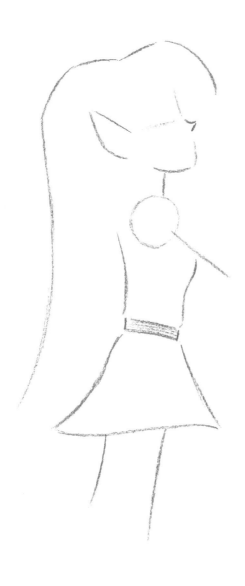

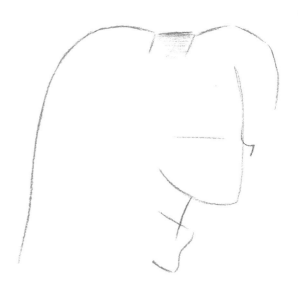

6

Conjure Up
Magical Powers

Fairies are born with special powers. Not all of them are
impressive—like the ability to yawn backward. Other powers
are amazing—like the ability to lift a thimble overhead with
one arm. In this chapter, I've selected only the most impressive
powers as examples. Here are a few additional powers you
could use as you draw your fairies: invisibility, transmutation
(turning into something else), and seeing through stuff.

Magic Wand

The wand is part of the starter set for a fairy's magical powers. With this one instrument, your fairy can create a trainload of bubbles.

No one has yet figured out anything useful to do with bubbles. But that's a minor detail. When a fairy graces the landscape with bubbles, it's a portent of something good to come. Like more bubbles, maybe. Wands are generally held high, and away from the body. You can follow my examples or draw your own.

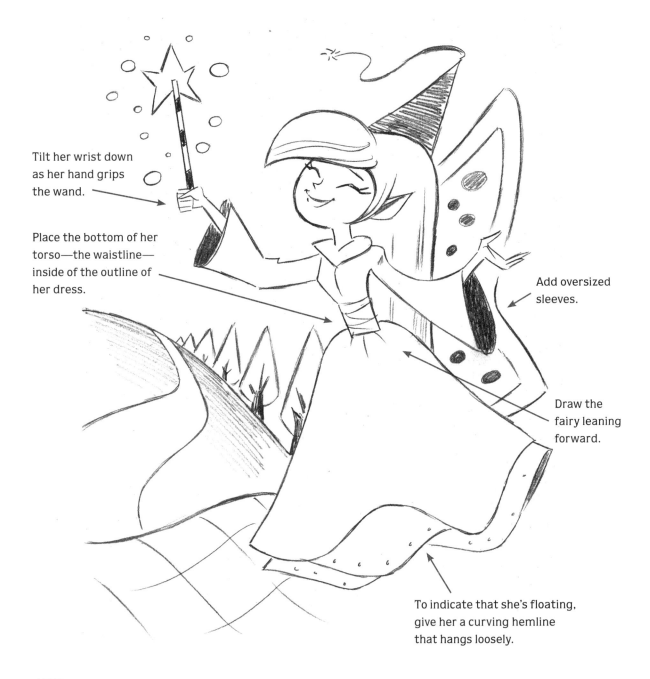

Tilt her wrist down as her hand grips the wand.

Place the bottom of her torso—the waistline—inside of the outline of her dress.

Add oversized sleeves.

Draw the fairy leaning forward.

To indicate that she's floating, give her a curving hemline that hangs loosely.

Power Up This Enchanted Fairy.

Show her in a balanced position with an arm on either side of the body.

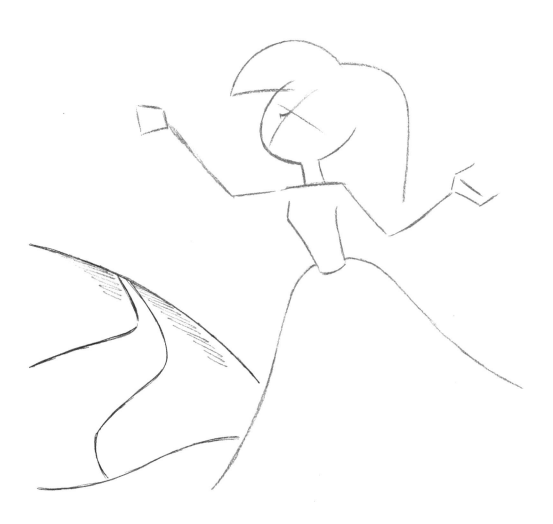

POWER VARIATION

The decoration at the top doesn't need to match the decorations on the rest of the staff.

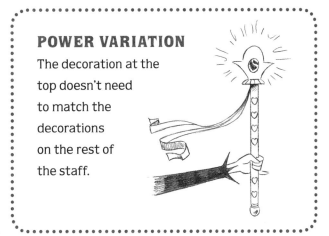

Conjuring

When you bring forth a spirit, it may not always be the one you were expecting. Sometimes, it's your dad demanding to know if you took the keys to his wings. Of course, you didn't. You would never have done that. Someone else must have done that. You definitely didn't do that. You're almost certain. . . . When putting this picture together, look to create a sense of interaction between the two characters.

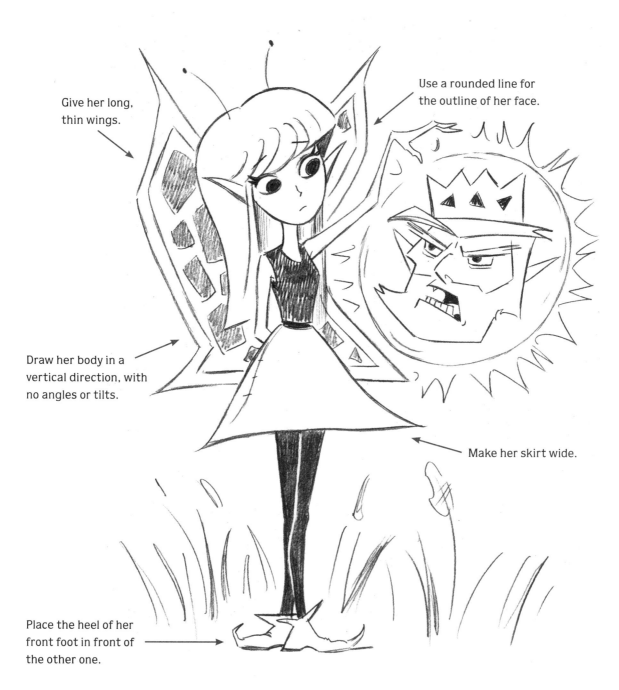

Give her long, thin wings.

Use a rounded line for the outline of her face.

Draw her body in a vertical direction, with no angles or tilts.

Make her skirt wide.

Place the heel of her front foot in front of the other one.

Power Up This Teen Fairy.

There's a lot going on in this scene, so try to keep her gestures simple, so it won't be hard to read.

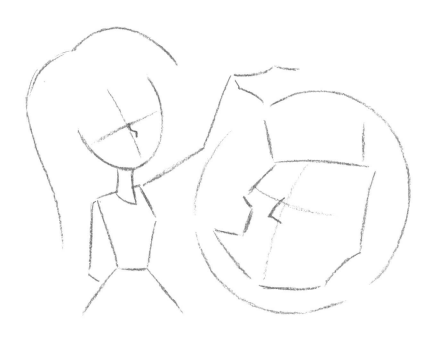

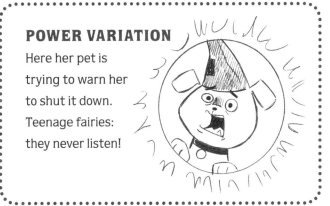

POWER VARIATION

Here her pet is trying to warn her to shut it down. Teenage fairies: they never listen!

Weightlessness

Being weightless can have many advantages for a fairy. She can stand on a tall blade of grass and act as a lookout. When a toddler lets go of a balloon, she can catch it before he starts to cry. And she can even imitate an astronaut doing somersaults in lunar orbit. She gets a lot of requests for that last one. Put a little spring in that blade of grass and finish the fairy on the opposite page.

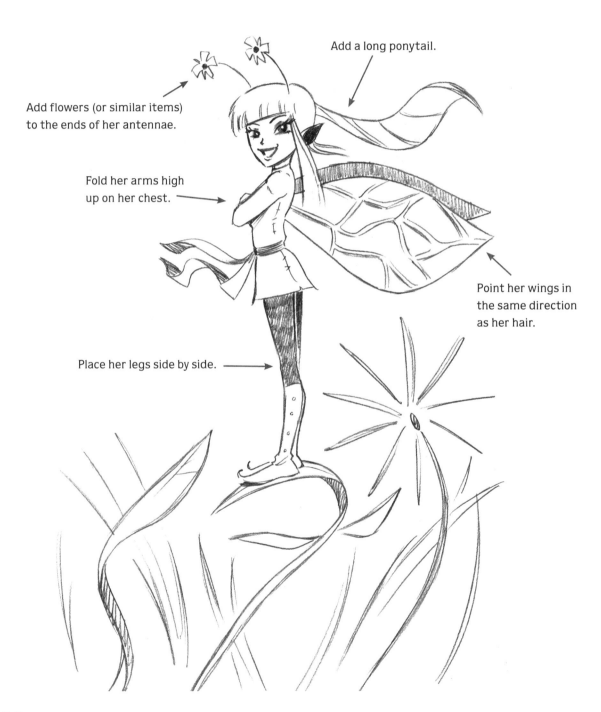

Add a long ponytail.

Add flowers (or similar items) to the ends of her antennae.

Fold her arms high up on her chest.

Point her wings in the same direction as her hair.

Place her legs side by side.

Power Up This Lighter-Than-a-Feather-Fairy.

At the top of a blade of grass, the altitude is so high that the wind blows like crazy. So show that in her hair and belt.

Wind Power

Fairies use this power primarily for gags and practical jokes. Ever see a businessman walking down the street, only to have his briefcase suddenly fly open? His papers are blown away and he can't catch them no matter how fast he runs. Curious, isn't it? (Fairies may be little, but that doesn't mean they're not also diabolical.) Finish the fairy character, and add the special effects.

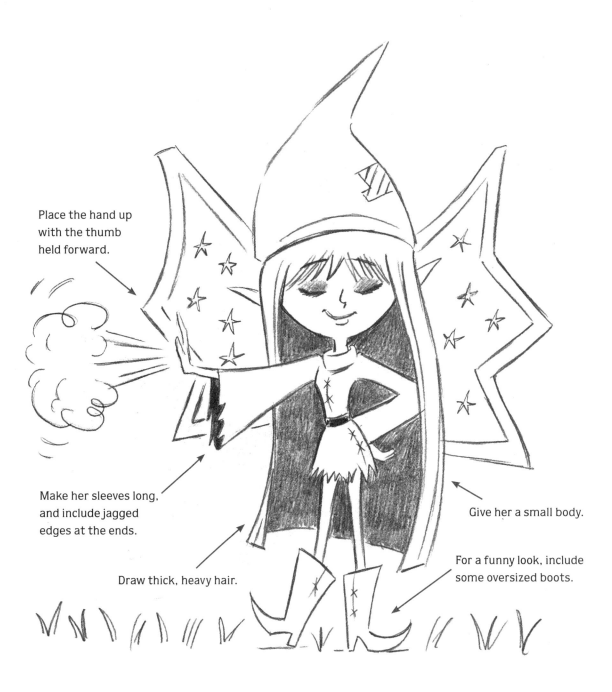

Place the hand up with the thumb held forward.

Make her sleeves long, and include jagged edges at the ends.

Draw thick, heavy hair.

Give her a small body.

For a funny look, include some oversized boots.

Power Up This Windy Fairy.

She's such a master of this technique that she can do it with her eyes closed. Draw her facing forward in a front view, while exerting her powers to the side.

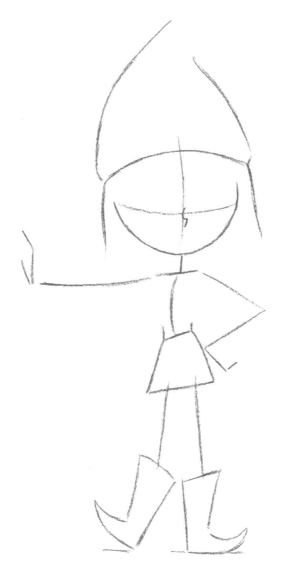

POWER VARIATION
Zapping is an even more mischievous version of wind power.

Beckoning Buddies

This fairy has the ability to make things pop into existence. It could be anything . . . a tricycle or a polka-dotted unicorn. But for some reason, which I don't understand, it's never money. That would be the first thing I would do. Let's take a look at some of the magical creatures she comes up with. Draw this skillful fairy as she creates furry little playthings.

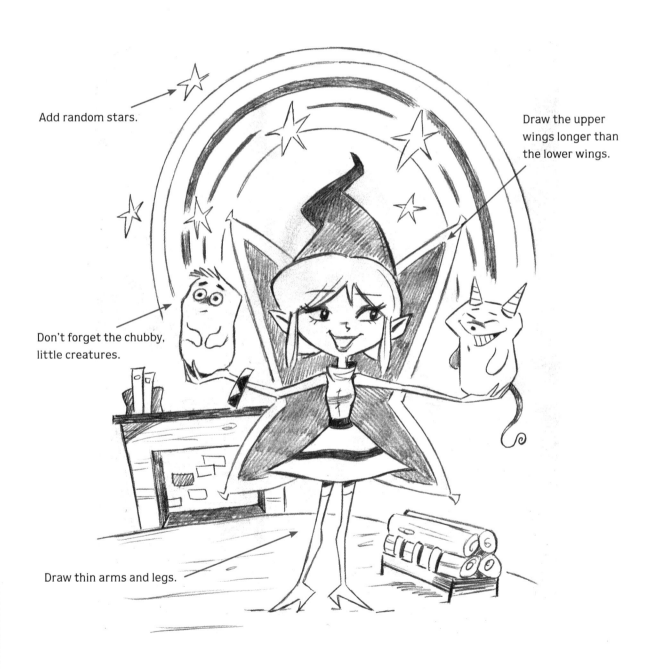

Add random stars.

Draw the upper wings longer than the lower wings.

Don't forget the chubby, little creatures.

Draw thin arms and legs.

Power Up This Playful Fairy.

When drawing fairy friends, draw them small enough for your fairy to hold, but big enough so that you can give them expressions and attitudes.

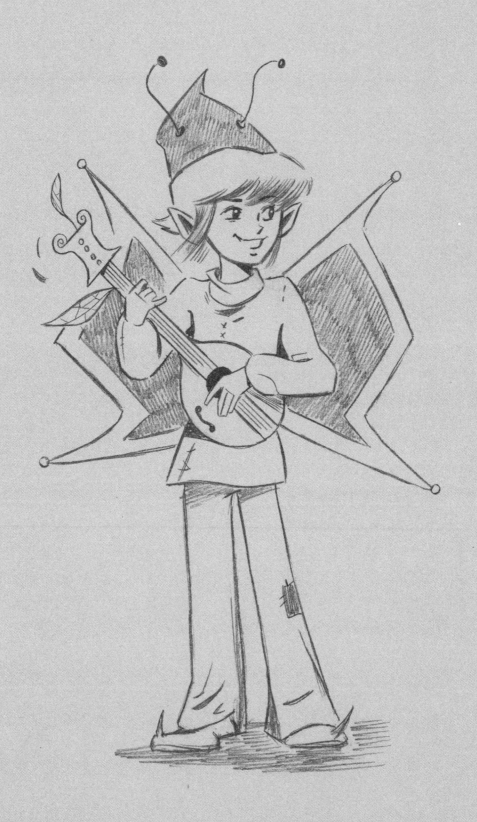

Finish Musical Instruments

The woods provide the perfect materials for creating fairy-sized musical instruments. Each morning, fairies rise at the crack of dawn and begin to play their instruments.

In this chapter, I'll start some drawings of fairies weaving a tune. And then you'll get to complete the scenes—fairies, instruments, and all.

The Maestro

Before I get to the instruments, let's first draw the fairy at the head of the woodland orchestra. He's the conductor (also referred to as the maestro). Perched on a flower, his job is to flap his arms and pretend to know what he's doing.

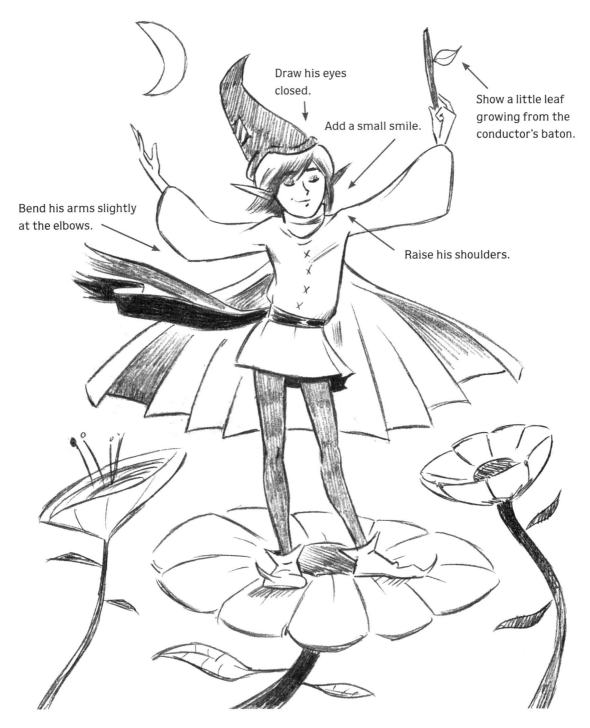

Draw his eyes closed.

Add a small smile.

Show a little leaf growing from the conductor's baton.

Bend his arms slightly at the elbows.

Raise his shoulders.

Tune Up This Band Leader.

Draw the maestro as he begins the morning symphony. Allow his clothing to hang loosely as he lifts his arms.

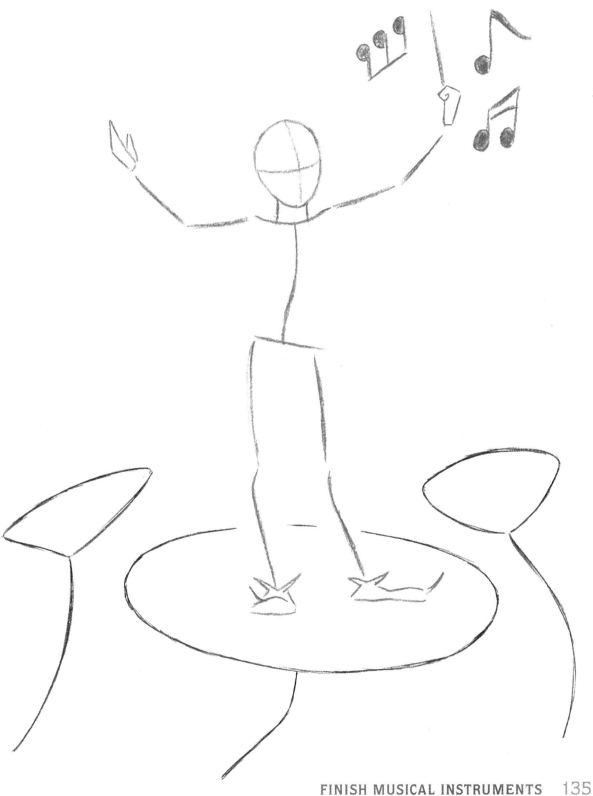

Pan Flute

You can't play this instrument for more than five minutes without making yourself dizzy. This fairy is drawn so that the flute overlaps her chin just slightly. It's also important to note that her mouth is drawn small.

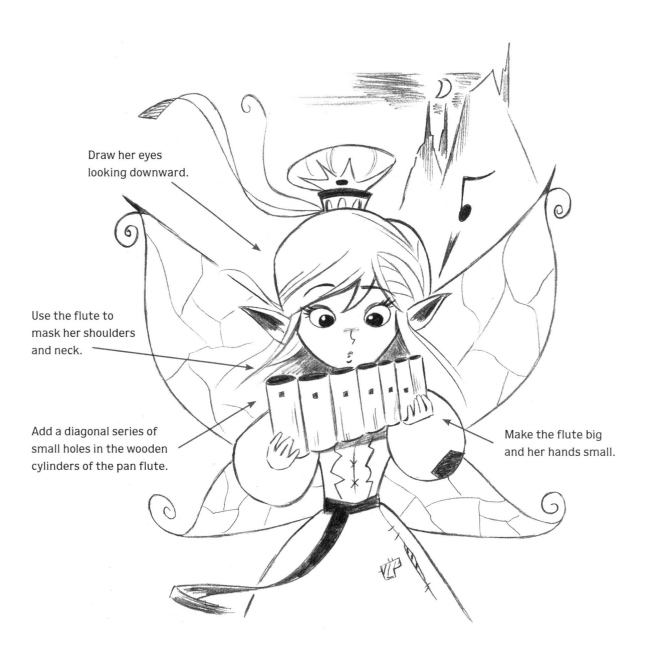

Draw her eyes looking downward.

Use the flute to mask her shoulders and neck.

Add a diagonal series of small holes in the wooden cylinders of the pan flute.

Make the flute big and her hands small.

Tune Up This Almost-Talented Fairy.

Draw a fairy in desperate need of private lessons. This drawing starts high on the right, and descends as it travels to the left. Allow the sleeves to billow out near the wrists.

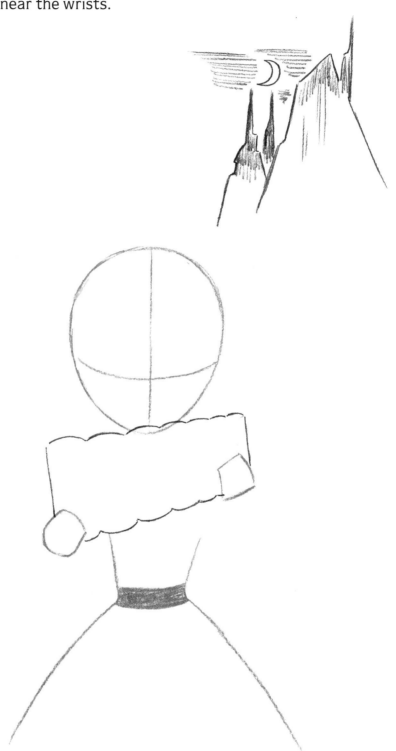

Guitar

This fairy plays lead guitar in her band, The Bouncing Acorns. They have a manager, a booking agent, and a lawyer. Now all they need are some fans.

So far, they're pretty popular with squirrels and hedgehogs. That's a start. She has a cool style of dress and a charisma that gets her fans on their feet.

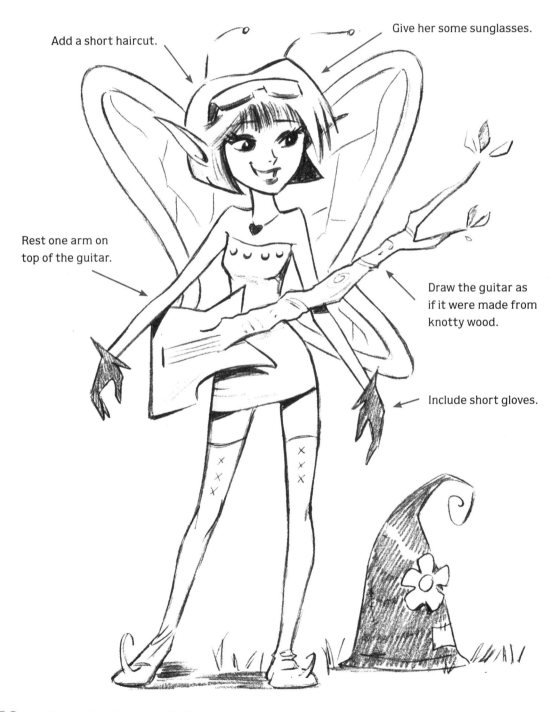

Add a short haircut.

Give her some sunglasses.

Rest one arm on top of the guitar.

Draw the guitar as if it were made from knotty wood.

Include short gloves.

Tune Up This Rockin' Fairy.

Before she goes back on the road, draw this rock 'n' roll fairy. The body of the guitar rests on her hips, which helps it stay in place. Draw the wings behind her head. Doing so frames her face nicely—good for coloring!

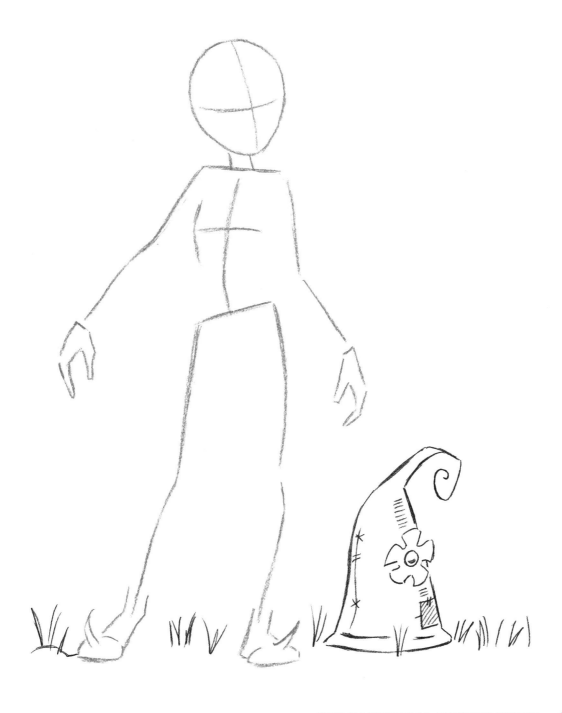

Mandolin

The mandolin conjures up images of the Middle Ages, when there were troubadours, jousts, and feasts—and astronomers were burned at the stake. Hey, no time is perfect. The mandolin is round and compact. Its association with the time of yore gives it a romantic flair. (What time is "yore" anyway? And how does anyone know when it's a quarter to yore?)

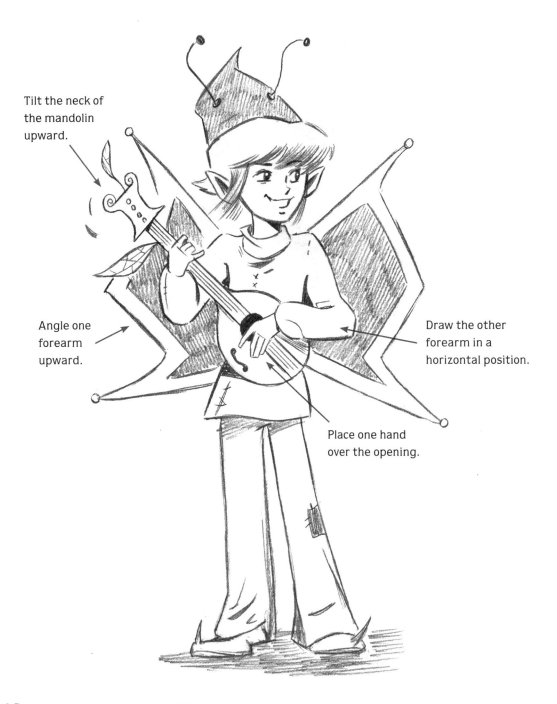

Tilt the neck of the mandolin upward.

Angle one forearm upward.

Draw the other forearm in a horizontal position.

Place one hand over the opening.

Tune Up This Off-Key Fairy.

Draw a mandolin, and add some chivalric flair to your fairy character. Make the shoulders square and set his legs shoulder length apart.

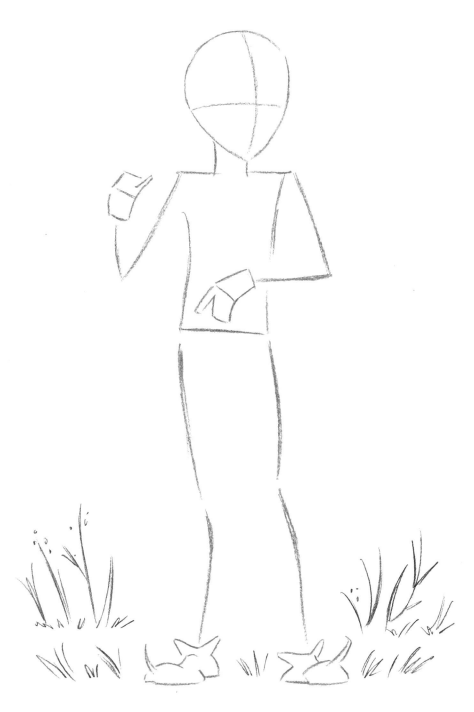

Ye Olde Trumpet

This fairy trumpeter blows his horn to notify everyone that it's time for the annual business meeting in the town square. Why does everyone show up to these boring events? It's the only way to get him to stop blowing his horn.

Draw hearts, flowers, or anything else you can think of coming from the bell of the trumpet.

Give him closed eyes and big cheeks.

Show his two hands touching.

Place his elbow out in front of his body.

Draw the legs side by side.

Tune Up This Very Loud and Annoying Fairy.

Draw the fairy trumpeter, who only needs to know how to play one note. The horn is such a linear instrument. You either have to position it horizontally or diagonally. I think you'll find that diagonally is more engaging.

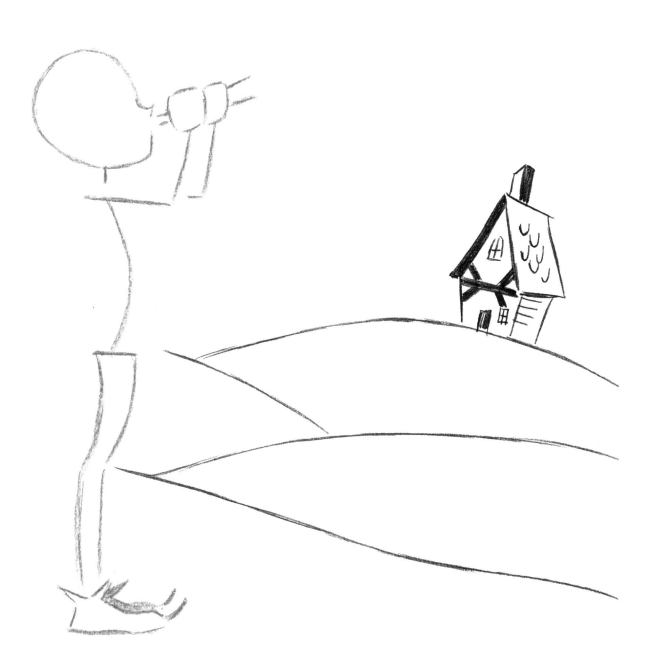

Harp

The harp is one of the two most prized instruments in the fairy village. The other is the diamond-encrusted harmonica. (That's because of the diamonds.) Anyway, it's fun to draw fairies playing their instruments while they float in the air.

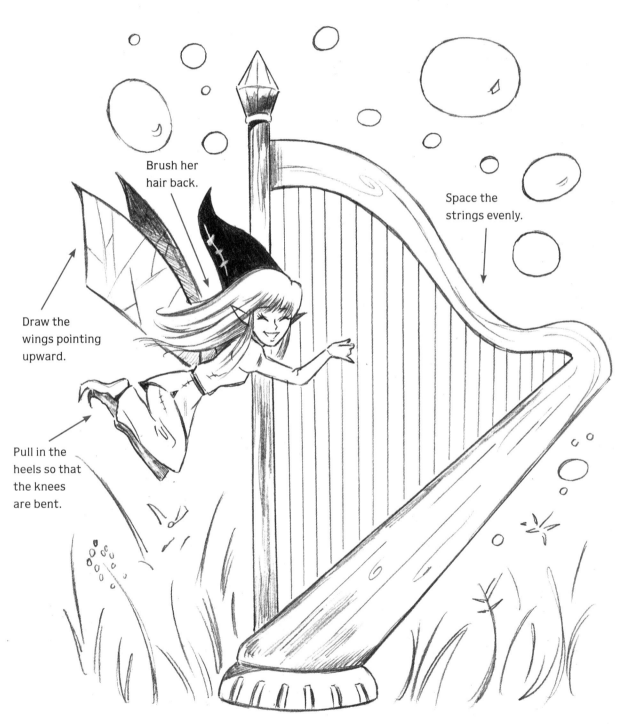

Brush her hair back.

Space the strings evenly.

Draw the wings pointing upward.

Pull in the heels so that the knees are bent.

Tune Up This Fairy with Pluck.

Draw this musical being picking at the strings. Harpists are skilled. As a signal of her control, pose her floating in the air with knees bent and squeezed together, showing perfect poise.

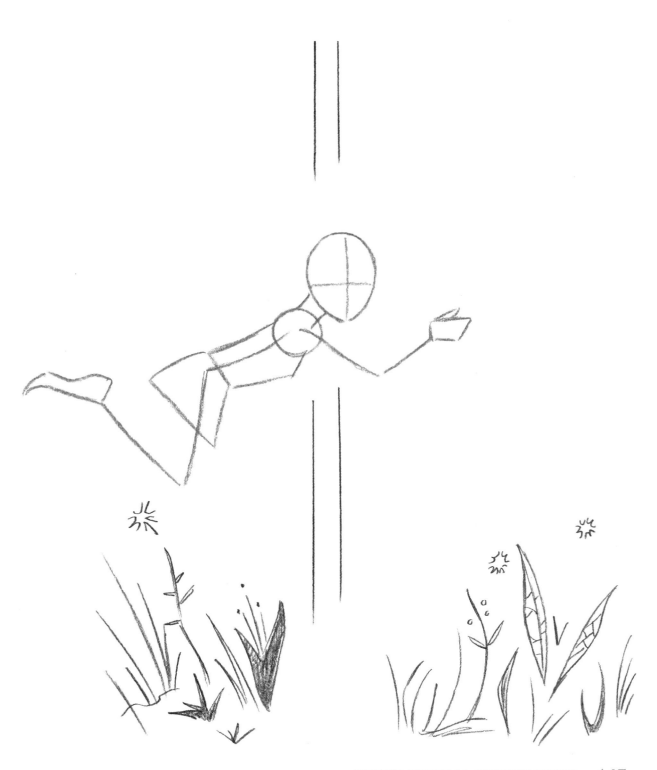

Xylophone

For years, people have wondered why xylophone doesn't start with a Z. It's because "zxylophone" looks even weirder.

Position the mallets so that they don't overlap the edges of her wings. Doing this makes them easier to see.

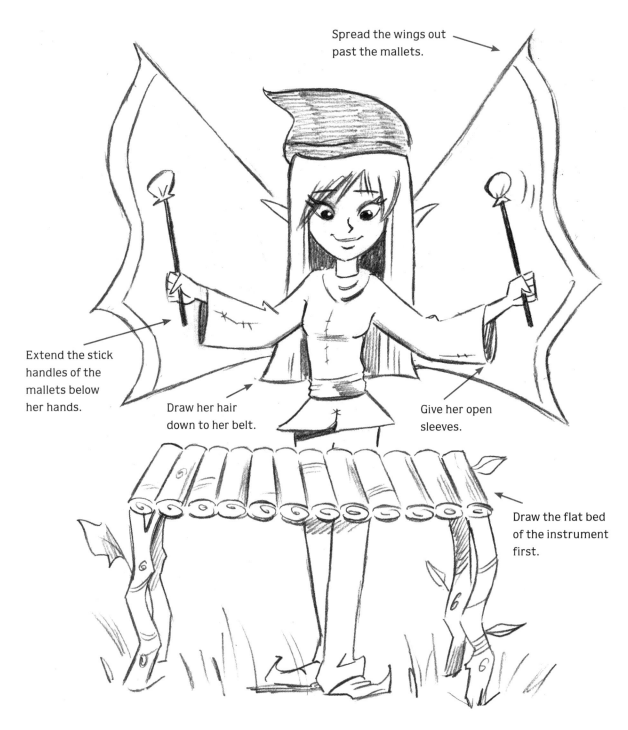

Spread the wings out past the mallets.

Extend the stick handles of the mallets below her hands.

Draw her hair down to her belt.

Give her open sleeves.

Draw the flat bed of the instrument first.

Tune Up This Bing-Bong-Bing Fairy.

Take out your pencil, and get ready to make music. She looks like my uncle Max one second before he dives into an all-you-can-eat buffet. Show her enthusiasm for music by lifting the arms to chest level, and placing them away from her body.

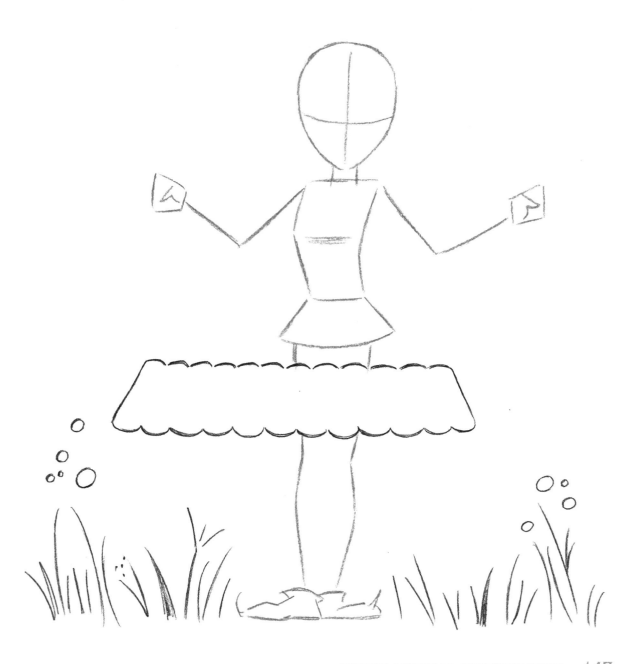

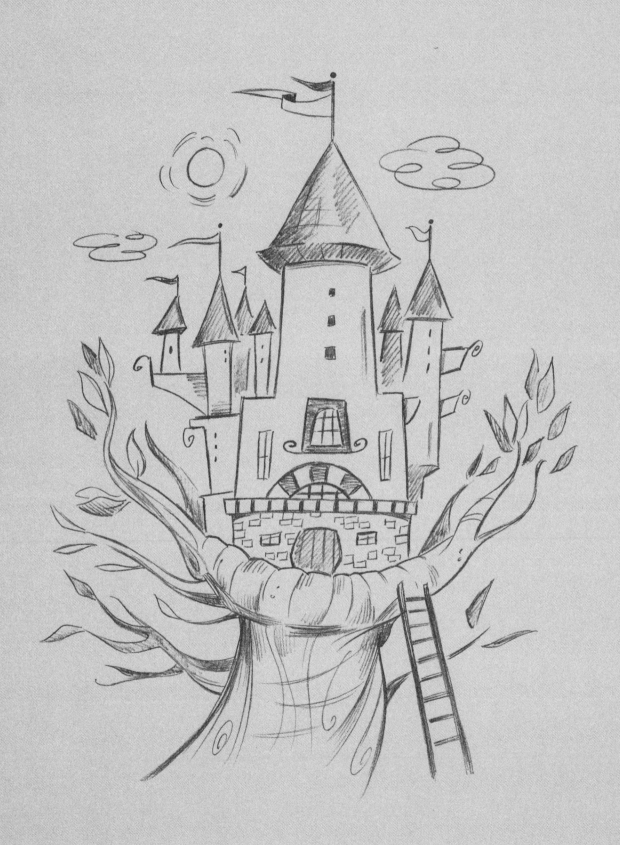

Design Fairy Dwellings

I'm not giving away any big secret when I tell you that fairies live in the woods; however, just like people, fairies have different tastes in houses. I'll show you many of these tiny habitats and give you a chance to complete your own.

Tree House

When I was a kid, I wanted to live in a tree house in my backyard—which tells you something about my family life. For fairies, the tree house is their main house. Instead of being located in the branches, where it would be vulnerable, the fairy tree house is built into the base of a tree trunk. Don't forget: it's important to draw the grain of the wood so that the tree doesn't look flat and empty.

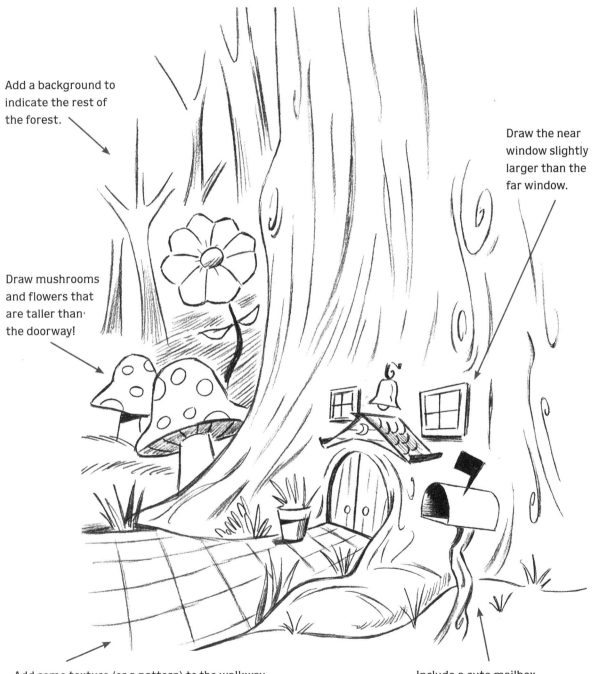

Add a background to indicate the rest of the forest.

Draw mushrooms and flowers that are taller than the doorway!

Draw the near window slightly larger than the far window.

Add some texture (or a pattern) to the walkway.

Include a cute mailbox in the foreground.

Finish This Tree House.

Draw home sweet home for a family of fairies. No straight lines for trees!
Use long lines that gradually widen to the base of the tree.

Fairy Village

The high-pitched, tiled roofs add an old-world charm. Packing neighbors close together provides safety but also makes it embarrassing to dart out the front door in the morning to get the paper in your bathrobe. The village looks humorous because each house is drawn at a different angle.

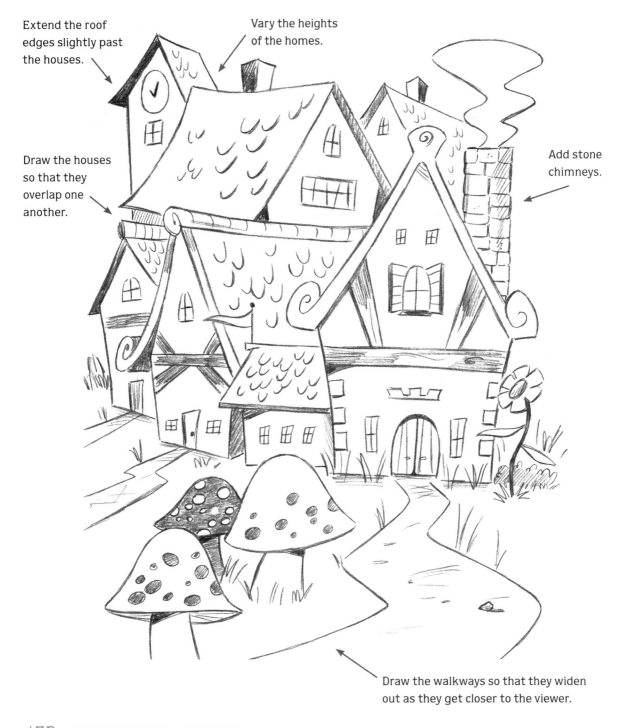

Extend the roof edges slightly past the houses.

Vary the heights of the homes.

Add stone chimneys.

Draw the houses so that they overlap one another.

Draw the walkways so that they widen out as they get closer to the viewer.

Finish This Fairy Village.

Draw a bunch of quaint but cramped houses. Don't worry if your houses don't all seem to go together. Part of the charm is that they don't!

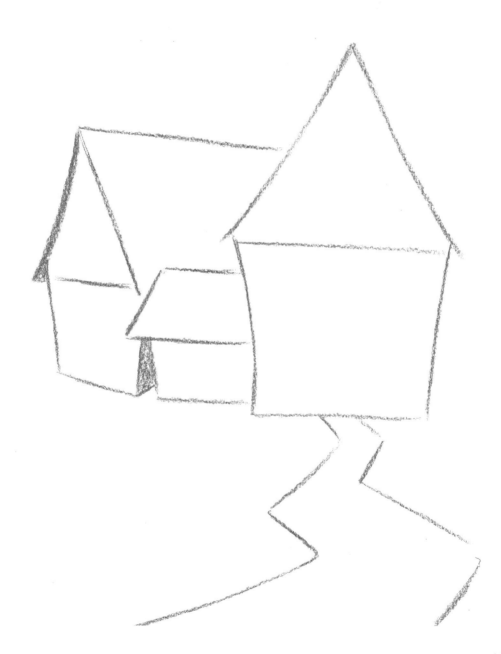

Castle in the Forest

A hidden castle in the forest is a romantic notion. But while it is isolated and well protected, it can be a real pain to get wi-fi. Nonetheless, these castles hold a special place in the heart of everyone who likes a good dungeon. The tree provides a solid base. It has to be as convincing as the castle.

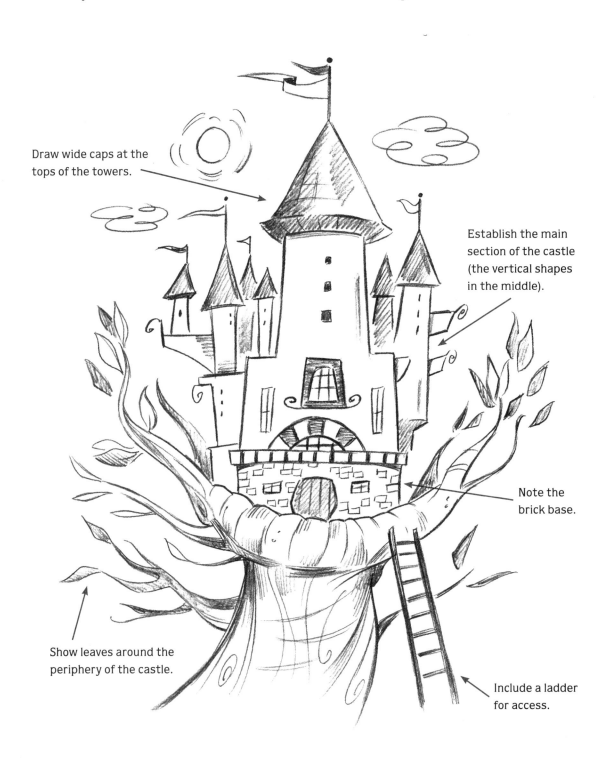

Draw wide caps at the tops of the towers.

Establish the main section of the castle (the vertical shapes in the middle).

Note the brick base.

Show leaves around the periphery of the castle.

Include a ladder for access.

Finish This Hidden Castle.

Draw a fortress that is strong enough to keep out curious salamanders. Although the castle is certainly vertical, especially the middle spire, it also widens out.

Recycled Home

Not every human recycles. And that's exactly what fairies count on. Fairies will take anything humans discard and put it to good use: an empty milk carton, an opened can of string beans, an old sweaty sock . . . well, maybe not the sock. This carton makes the perfect multi-story condominium for these tiny beings. Focus on copying the angles at the top of the carton. The rest of the carton is just a rectangle.

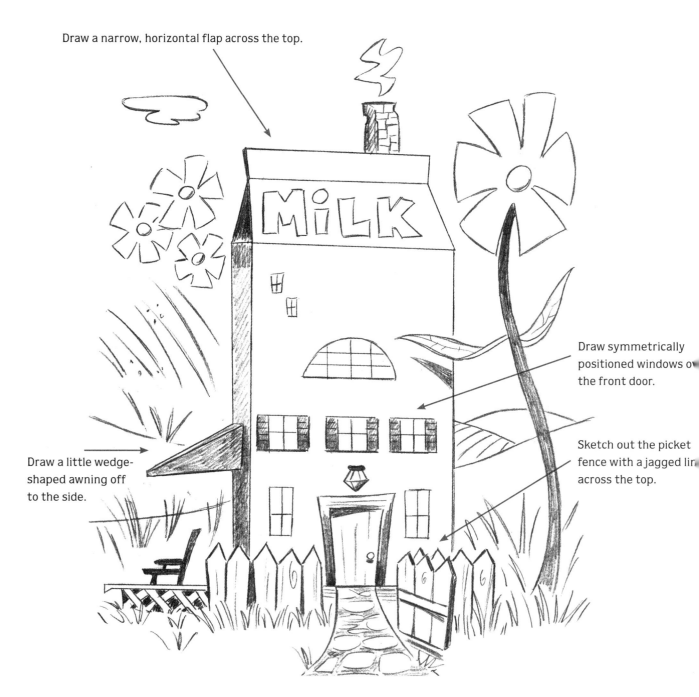

Draw a narrow, horizontal flap across the top.

Draw symmetrically positioned windows o[ver] the front door.

Draw a little wedge-shaped awning off to the side.

Sketch out the picket fence with a jagged li[ne] across the top.

Finish This Milk Carton Home.

Draw the house that builds strong bones. This one is a balancing act: add enough doodads to turn it into a fun, multi-fairy dwelling, but don't go overboard with the additions—you still need to be able to recognize it as a milk carton.

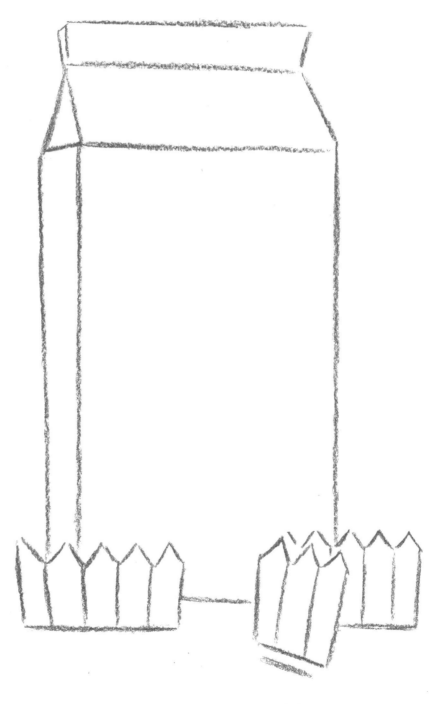

The Realm of Fantasy

From glistening ponds to gentle streams and hills to the skies and clouds above, in all these places you will find the fairies spreading joy and good cheer. I'm so happy I've had a chance to share their charm and antics with you—and also to provide some inspiration for your own artistic creations. May the wind be at your back, filling your wings and carrying you ever forward to your dreams.

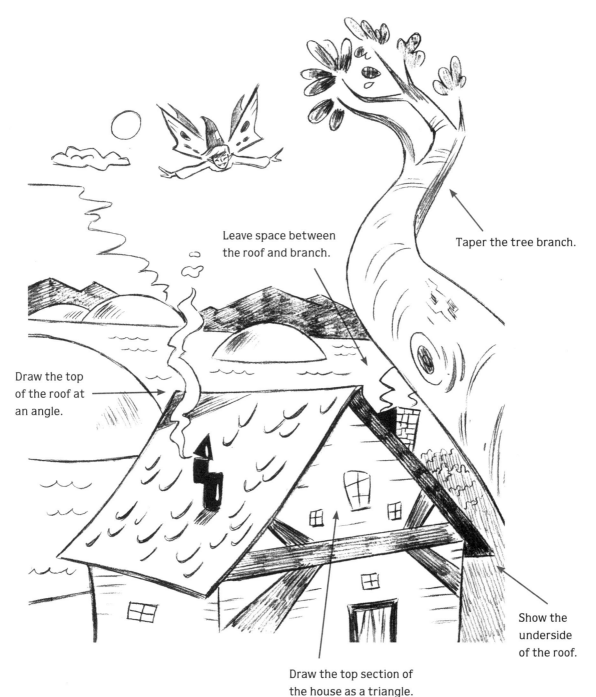

Leave space between the roof and branch.

Taper the tree branch.

Draw the top of the roof at an angle.

Show the underside of the roof.

Draw the top section of the house as a triangle.

Finish This Fairy Farewell.

Draw a friendly fairy coming to say hello—never good-bye! Block out the major areas and defining lines first—water line, mountain range, Tudor trim on the house, and so on. Get everything where you want it, then enjoy drawing in the details!

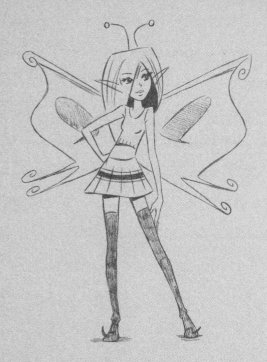

For all my fans who have subscribed to and commented on my YouTube channel.

Published in the United States by Watson-Guptill Publications, an imprint of the Crown Publishing Group, a division of Penguin Random House LLC, New York.
www.crownpublishing.com
www.watsonguptill.com

WATSON-GUPTILL and the WG and Horse designs are registered trademarks of Penguin Random House LLC.

Library of Congress Cataloging-in-Publication Data
Names: Hart, Christopher, 1957- author.
Title: Doodletopia. Fairies : draw, design, and color your own super-magical and beautiful fairies / Christopher Hart.
Description: First Edition. | Berkeley : Watson-Guptill, 2016. | Includes bibliographical references and index.
Identifiers: LCCN 2016020647 | Subjects: LCSH: Fairies in art. | Drawing—Technique. | Doodles. | BISAC: ART / Techniques / Drawing. | ART / Techniques / Cartooning. | ART / Popular Culture.
Classification: LCC NC825.F22 H365 2016 | DDC 741.5/1—dc23
LC record available at https://lccn.loc.gov/2016020647

Trade Paperback ISBN: 978-1-60774-695-9

Printed in the United States of America

Design by Chloe Rawlins

10 9 8 7 6 5 4 3 2 1

First Edition